DOGS HANGING OUT OF WINDOWS

This edition first published in Great Britain in 2014 by Orion
an imprint of the Orion Publishing Group Ltd
Orion House, 5 Upper St Martin's Lane,
London WC2H 9EA
An Hachette UK Company

1 3 5 7 9 10 8 6 4 2

A CIP catalogue record for this book is available from the British Library.

Hardback ISBN: 978 1 409 15012 1

Desgined by: Smith & Gilmour

Photograph Copyright:
Andrew Paniwozik: page 96/97; Ian Wedlock: page 19; iStock: page 36, 37, 39, 40/41, 42, 43, 45, 46/47, 48, 49, 50, 51, 52/53, 54,
55, 56/57, 58, 59, 60/61, 62, 63, 64/65, 66/67, 68, 69, 70/71, 72, 73, 76, 77, 80, 81, 82; Gisele dos Santos: page 136/137; Kate
Smith: page 30; Shutterstock.com: page 14, 16/17, 24, 31, 34/35, 38, 44, 77/78, 84, 85, 89, 90/91, 92/93, 95, 98/99, 100, 101,
102/103, 104/105, 106, 107, 108/109, 110, 111, 112/113, 116/117, 122/123, 124, 128; William Hartley: page 7, 10/11, 12/13,
18, 20, 21, 22, 23, 26/27, 28, 32, 33, 74, 83, 86/87, 94, 114/115, 118, 119, 120/121, 125, 126/127, 130/131, 132/133, 137/138.

With special thanks to: Laura Harper: page 134; Mid-Hudson Bloodhound Refuge: page 135;
Nick Hammick: page 88; Sally Felton: page 29; Sarah Tilley: page 129.

Printed in China

The Orion Publishing Group's policy is to use papers that are natural, renewable and recyclable and made
from wood grown in sustainable forests. The logging and manufacturing processes are expected to conform
to the environmental regulations of the country of origin.

Every effort has been made to fulfil requirements with regard to reproducing copyright material.
The author and publisher will be glad to rectify any omissions at the earliest opportunity.

www.orionbooks.co.uk

WITH SPECIAL THANKS TO SOME
OF OUR CONTRIBUTORS:

William Hartley

Nick Hammick

Sally Felton

Laura Harper

Mid-Hudson Bloodhound Refuge

Ian Wedlock

Gisele dos Santos

Andrew Paniwozik

Ears flapping, eyes wide and nose twitching: a dog hanging out of a car window is a wonderful sight.

This book celebrates this simple yet glorious pleasure… dogs caught in motion, travelling elevated across the land, fresh air washing over their furry faces. Contributions from around the world have resulted in a stunning compendium of photographs, from a Bernese Mountain Dog in the Lake District sunset, to a Cairn Terrier in California and a Shih Tzu in Tennessee – this is a truly eye-opening project.

Dogs Hanging Out of Windows captures moments of delight and curiosity and features dogs of all shapes and sizes. Some look funny. Some look wise.

Some look wild. But whether cute, powerful, uplifting or heart-warming, these striking images demonstrate why we feel such love for our canine companions.

In over ninety-five incredible portraits, this collection showcases some of the best and most vibrant pet photography from around the globe. Guaranteed to raise a smile, this beautiful anthology of man's best friend in motion will hopefully bring you as much enjoyment as it has for us.

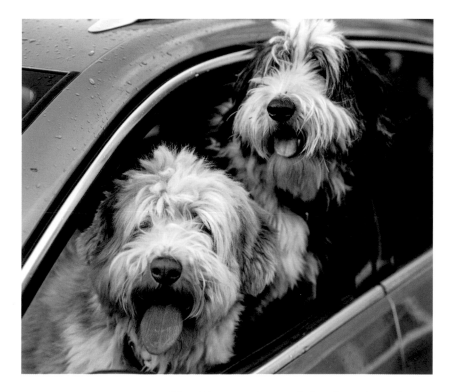

OLD ENGLISH SHEEPDOG These big strong dogs need a lot of exercise, and an owner who is prepared to spend some time grooming - their thick, shaggy coats can grow over their face and eyes. They seem to have a shuffling and bearlike gait.

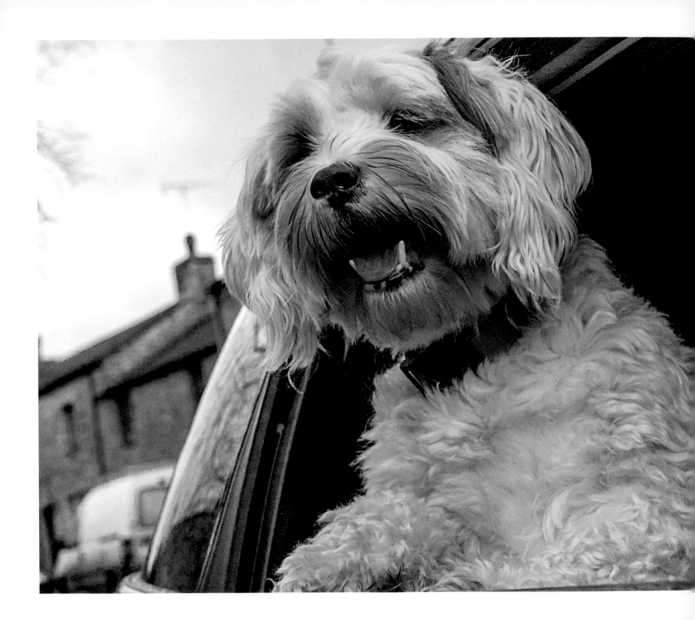

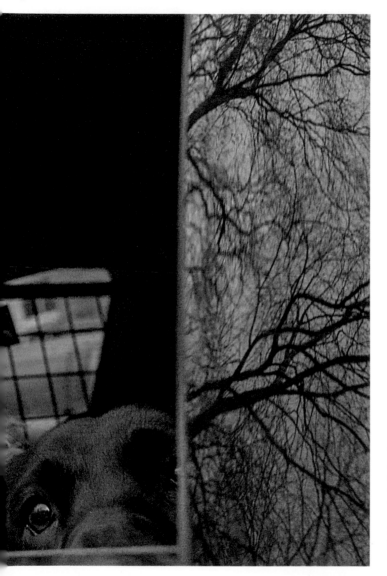

TIBETAN TERRIER *(left)* Nicknamed 'Holy Dogs' or 'Luck Bringers' these terriers were companions to Buddhist monks in Tibet. They were so valued that they were even referred to as 'the little people'.

BLACK BASSADOR *(right)* This breed is a cross between a Basset Hound and a Labrador Retriever.

COCKAPOO Cheeky cockapoo sticking its tongue out. These convivial dogs are wonderful companions and are a cross between a poodle and a cocker spaniel. As the original 'designer dog', they were first officially recognised as a breed in the 1960s.

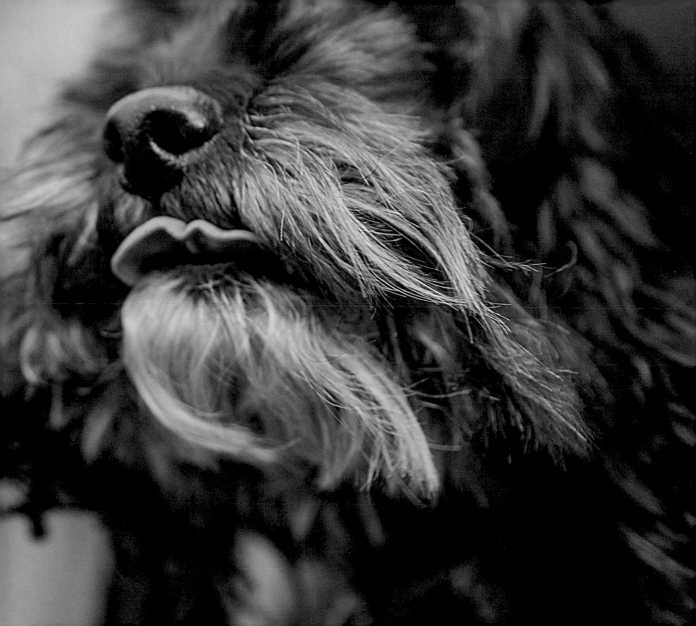

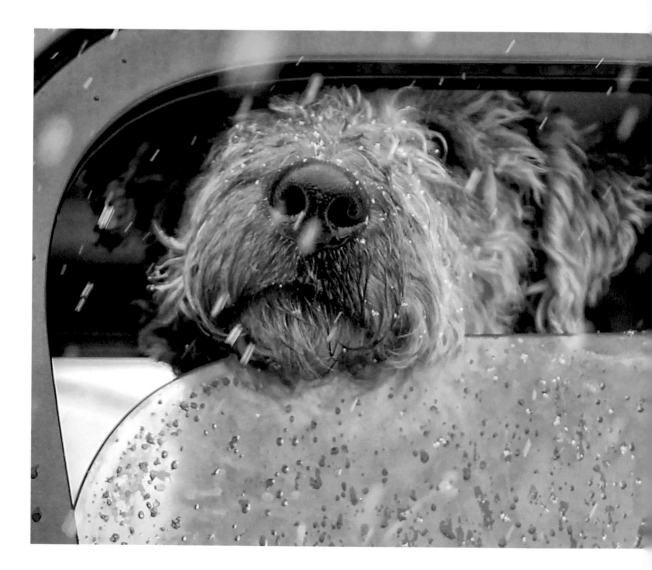

AIREDALE TERRIER 'An Airedale,' declared Teddy Roosevelt, 'can do anything any other dog can do, then whip the other dog, if he has to.'

BASSET HOUND With a sense of smell second only to the
Bloodhound, the Basset Hound was originally bred for hunting
rabbits and hare. Do not be deceived by their short stature: they
are surprisingly long and can reach things on tabletops that
dogs of a similar height cannot.

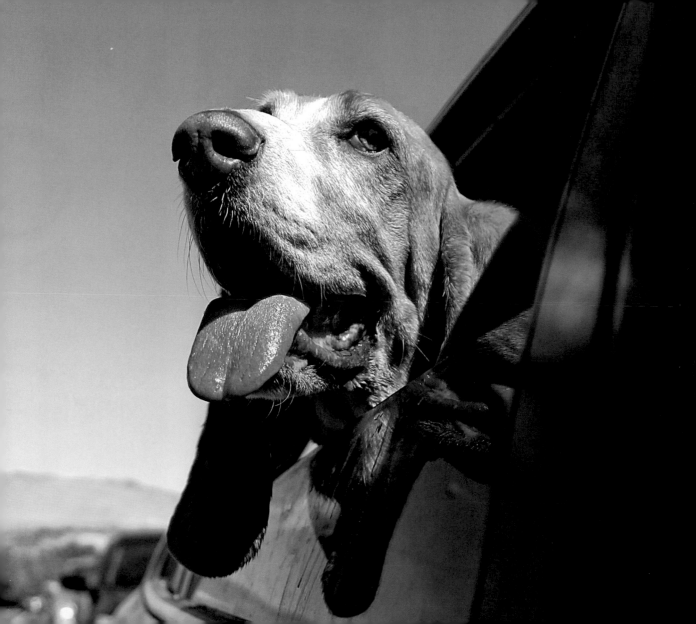

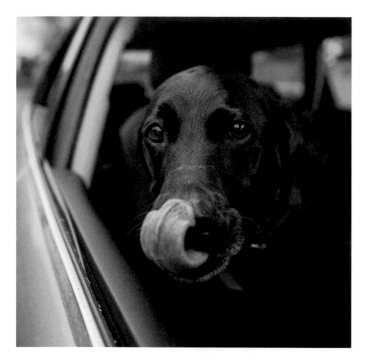

BLACK LABRADOR Topping 'popular dogs' lists for decades, these reliable, smart and steady dogs are renowned for their loyal character. Historically they were fishermen's helpers, but now are famous as guide dogs, gundogs and good friends.

SHIH TZU *(opposite)* Named using the Chinese for 'lion dog'. Bred to resemble lions in traditional oriental art, the Shih Tzu is the happy and hardy little dog famed for great hairstyles. This is Charlee, a brindle-coloured Shih Tzu aged five, in Tennessee.

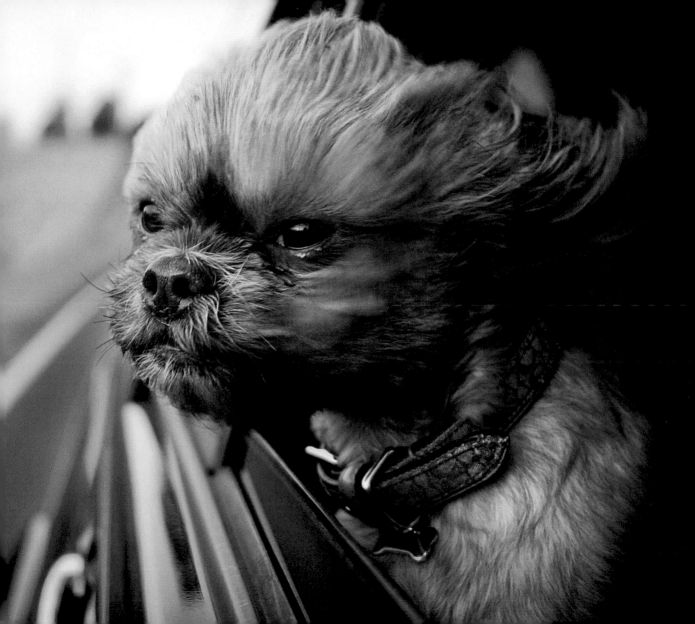

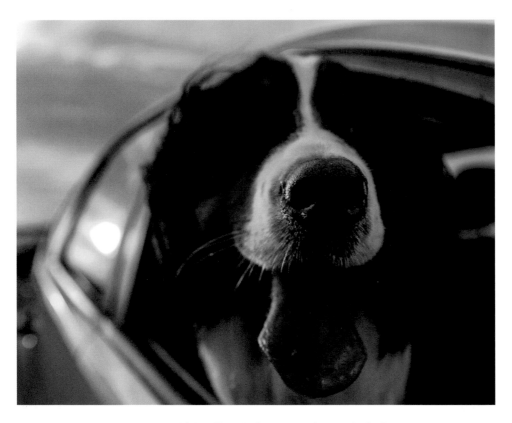

BERNESE MOUNTAIN DOG With its silky tricolour coat and attractive looks, the Bernese Mountain Dog is a beautiful and kind dog. It takes its name from the Swiss region of Berne, where they traditionally worked as haulage dogs for basket-weavers. This is Tia in the Cumbrian sunset.

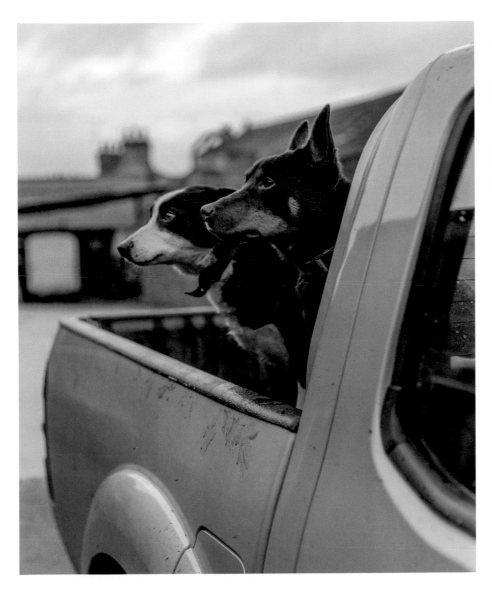

BORDER COLLIE *(left)*
Working farm dogs with a
natural herding instinct. The
Border Collie is known for his
intense stare which he uses to
keep his flock of sheep in check.

THE AUSTRALIAN KELPIE
(right) is a workaholic, all-action
dog, capable of herding cattle,
goats, poultry and even reindeer.
Timid owners will not do well
with a Kelpie.

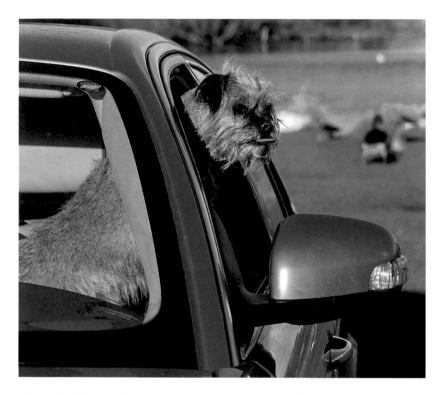

BORDER TERRIER Originally bred to drive foxes from hiding places on hunts, these cheerful and alert dogs have high energy levels – which can annoy owners who can't keep up. A bored Border is never a good thing.

BOXER *(opposite)* Boxers are well known for the cheeky glint in their eyes and their mischievous nature. They don't fully mature until three years old and even then their playful nature remains.

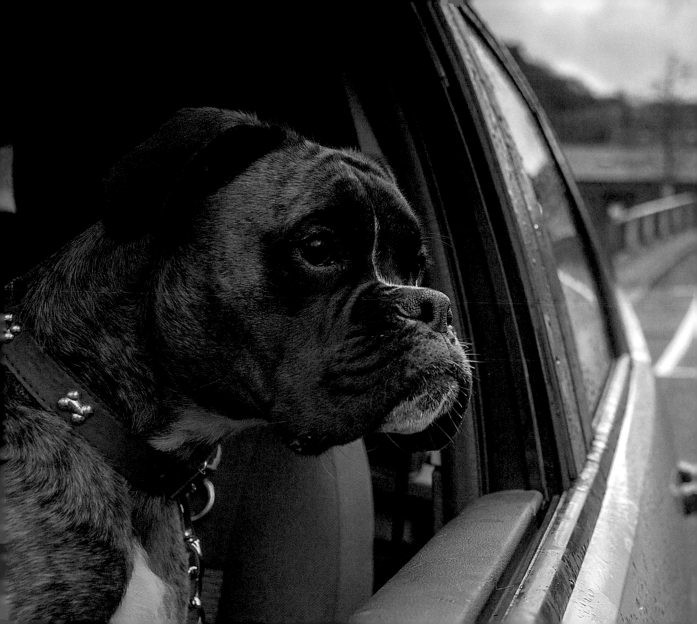

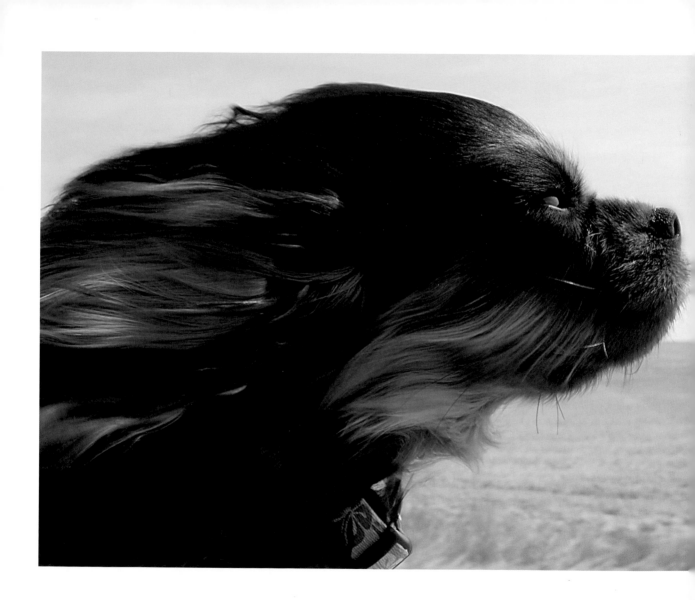

CAVALIER KING
CHARLES SPANIEL Top
tail-wagger. Cavalier King
Charles Spaniel breeders
strive to attain a tail that
stays in constant motion
while this dog is on the
move. With its plumy tail
and deep dark eyes, it's
almost impossible to resist
treating these trot-along
little dogs.

CAVALIER KING CHARLES
SPANIEL Cavaliers such as this
one, with rich chestnut markings
on an ivory white background,
are known as Blenheim in
honour of Blenheim Palace,
where John Churchill, 1st
Duke of Marlborough, raised
the predecessors to the breed
in this particular colour.

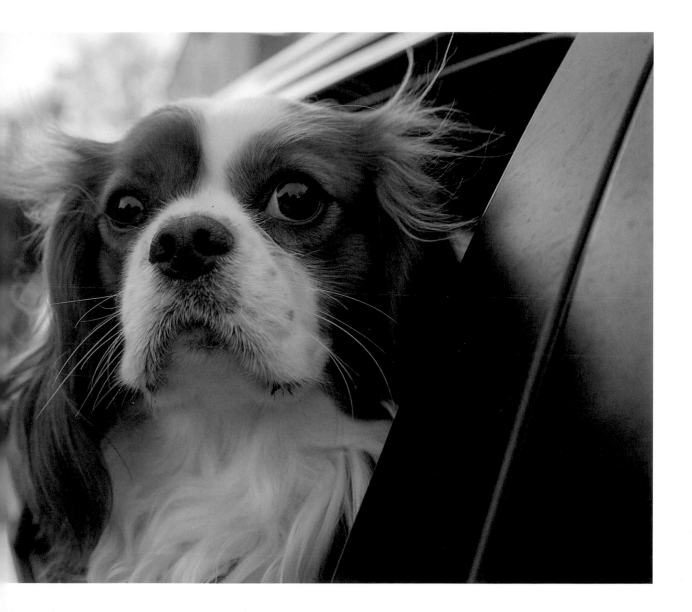

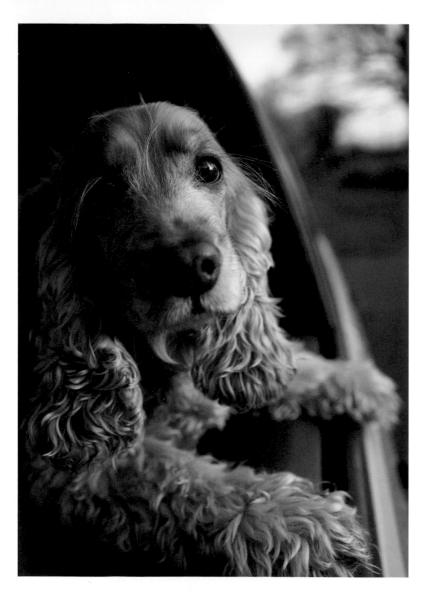

ENGLISH COCKER SPANIEL
Gentle and affectionate, this
gundog has an intelligent and
knowing expression. With an
ever-wagging tail and happy
disposition, the breed has earned
the nickname 'merry cocker'.
This is Flora.

WEST HIGHLAND WHITE
TERRIER *(opposite)* 'Westies'
are the pale cousins of the 'Scottie'
dog and have been around since
the 16th century. This is Millie,
ready for a spin in a convertible.
Living the dream.

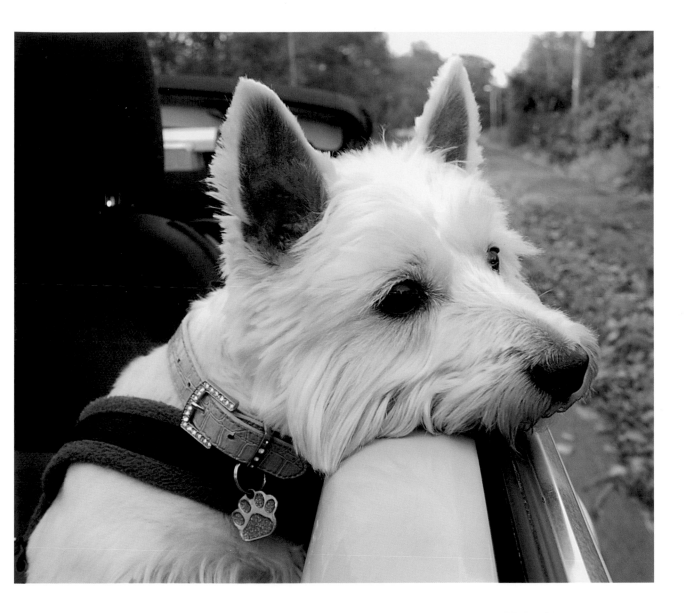

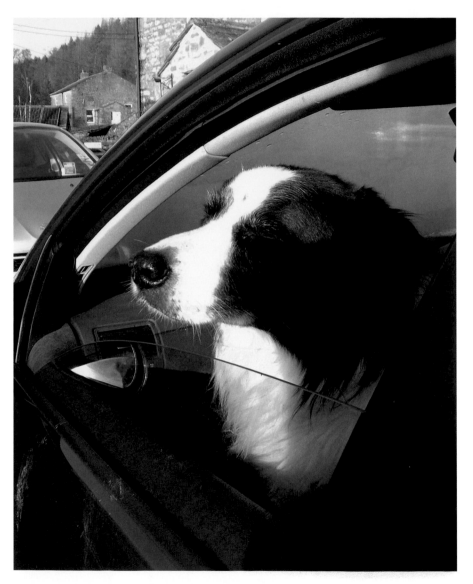

BORDER COLLIE Jack the Border Collie enjoys the breeze. Active and intelligent, these dogs have incredible working sheepdog abilities and a very low boredom threshold. Collie owners should be prepared to play repeated games of fetch.

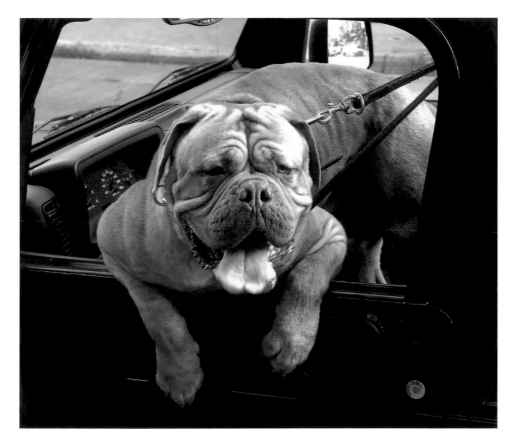

FRENCH MASTIFF Also known as the Dogue
de Bordeaux, these dogs are calm, sweet and
loyal. But they do tend to drool a lot.

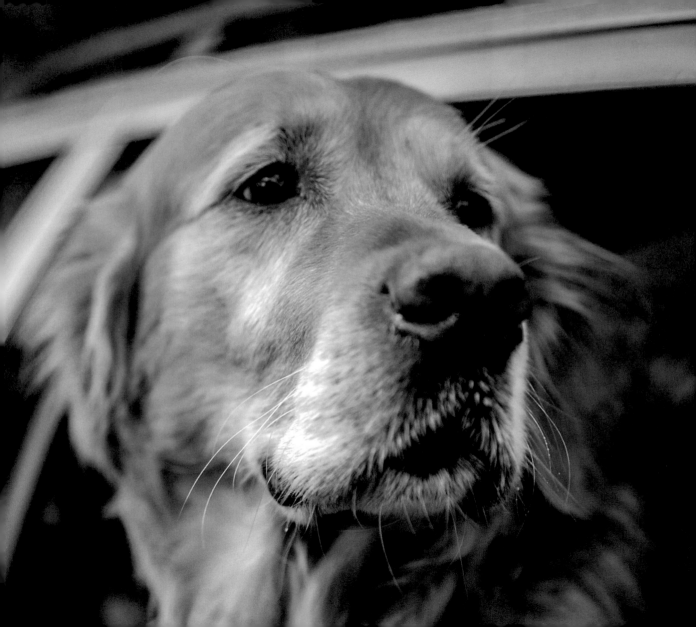

GOLDEN RETRIEVER
(opposite) The Golden Retriever
breed was originally developed
by Lord Tweedmouth. They like
to play fetch.

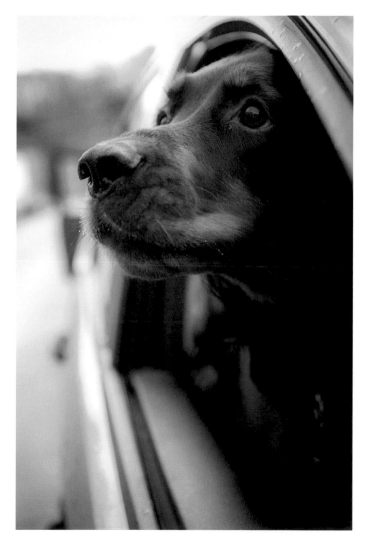

GORDON SETTER The biggest
of all the Setters, these dogs have
personality to match their size.
Gordon Setters are always eager
for attention and become very
attached to their owners – until
they pick up a scent and then
they're off.

IRISH SETTER The Irish Setter's blazing
red coat catapulted it from working gundog
to popular family pet. They are intelligent,
friendly and can be fiery in temperament. A
long walk might be needed to cool them down!

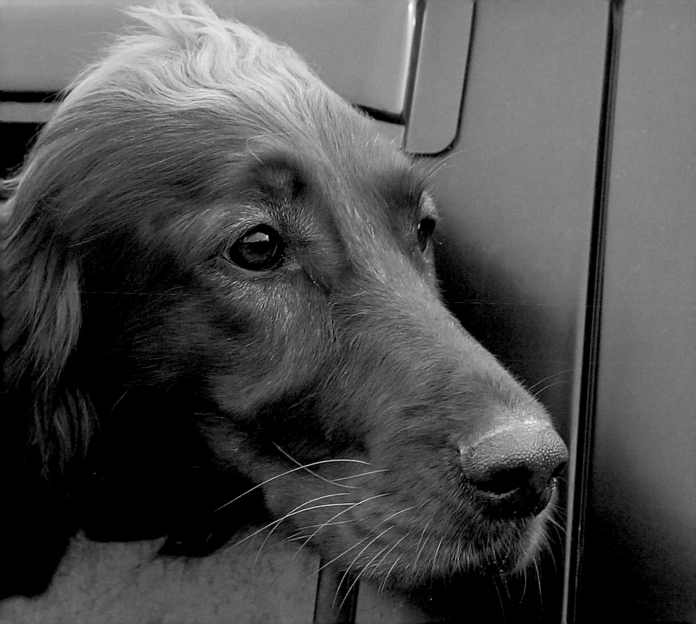

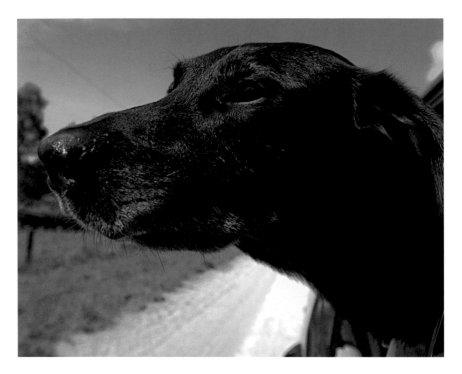

BLACK LABRADOR Despite their intelligence
and obedience, Labs are notoriously bad guard dogs.
Although they may bark at an unidentified sound,
they are not territorial and are simply too friendly.
To a Labrador, no visitor is unwanted.

BULLDOG *(opposite)* 'Don't mess with me.'
English Bulldogs are bred for their characteristic
large heads and stocky bodies, but these attributes
can be an issue – over 80 per cent of Bulldog
litters are delivered by Caesarean section.

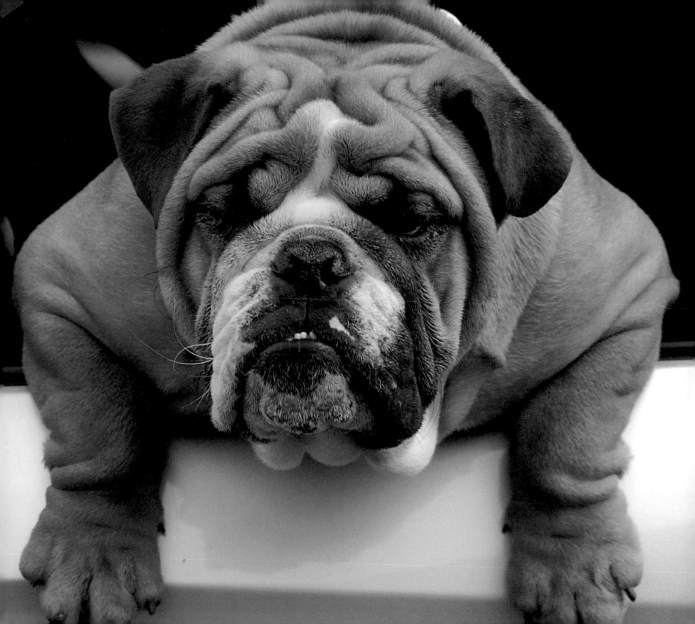

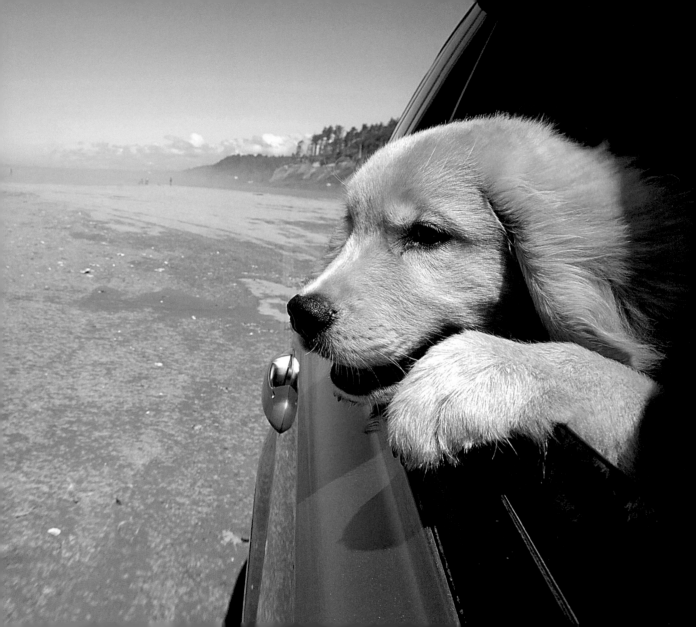

CHIHUAHUA MIX
Chihuahuas love burrowing themselves into their safe spaces or dens. But this mixed breed is enjoying a moment in the open air.

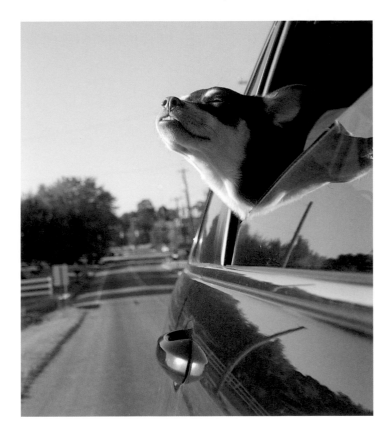

GOLDEN RETRIEVER *(opposite)*
Loving the ocean breeze. This young passenger laps up the beach air.

POODLE A life of leisure. This pampered poodle takes a joyride.

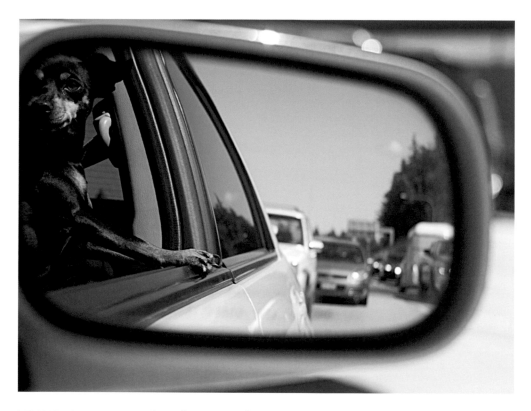

MINIATURE PINSCHER A stately stance on the motorway.
Known as 'King of Toys' the Min Pin packs a lot of attitude
into its small frame.

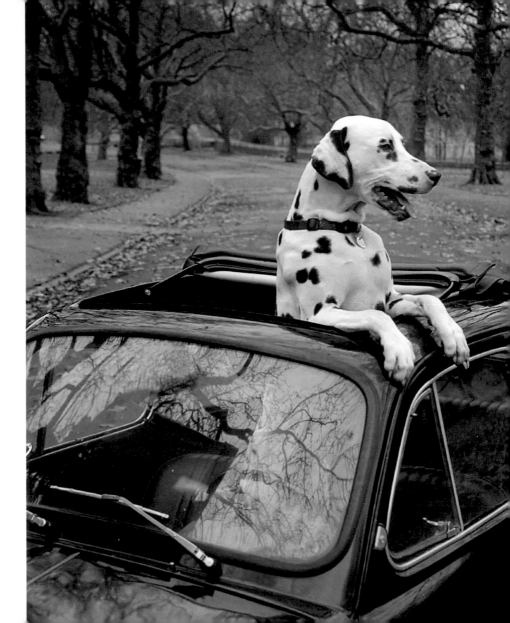

DALMATIAN Hitting the big time of dog breed fame in Disney's *101 Dalmatians* film, the Dalmatian was originally used to run alongside carriages and add a touch of flamboyance to the vehicles of travelling aristocrats.

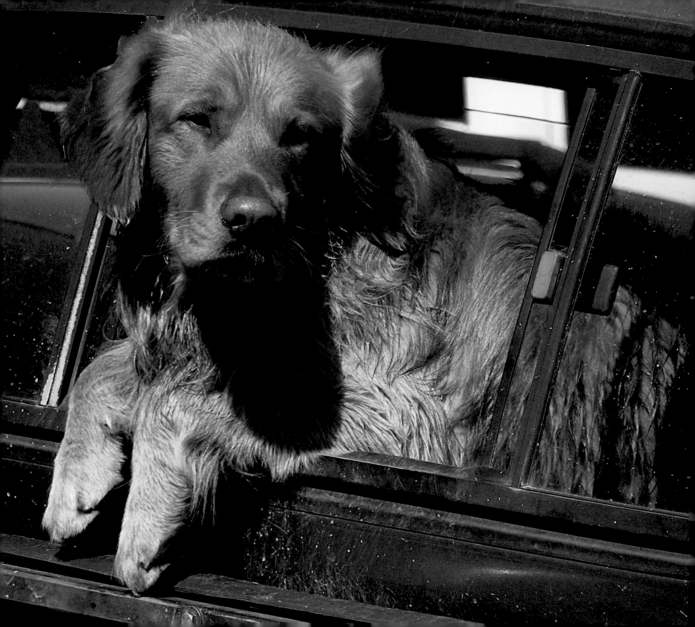

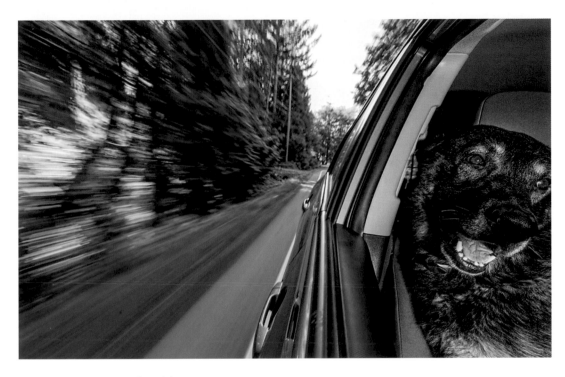

GERMAN SHEPHERD Speed demon
German Shepherd enjoys a fast ride.

GOLDEN RETRIEVER MIXED BREED
(opposite) Surveying his kingdom. Trademark
wise, brown eyes that exude intelligence.

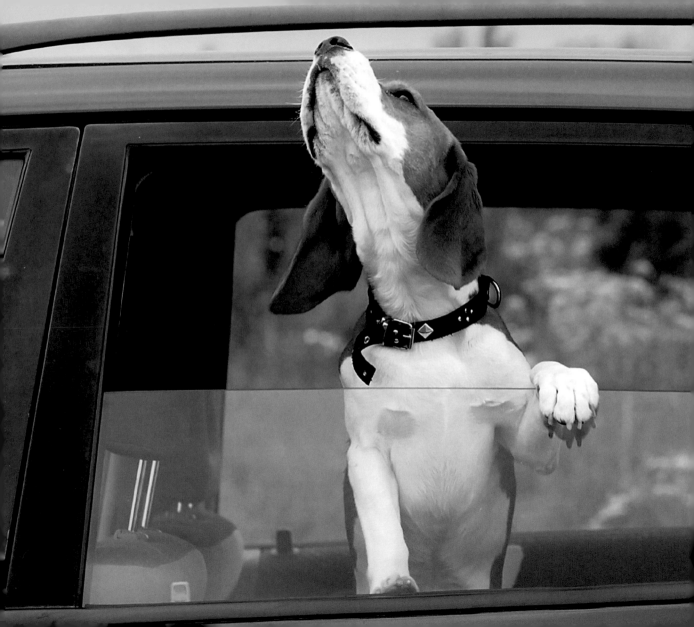

BEAGLE The beagle is sociable, brave and intelligent. With excellent hunting instincts, he sticks his tail straight up when actively following a scent and is known to utter a distinctive howl. Not to be trusted with non-canine pets.

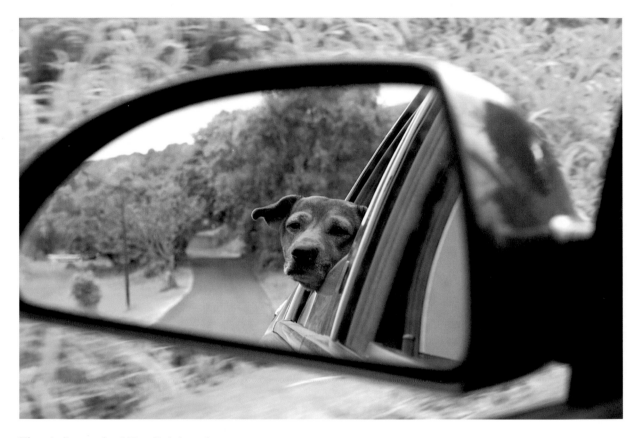

The winding roads of Hawaii. A dog takes
in the lush landscape on the island of Maui.

ROUGH-COATED TERRIER CROSS Lovers of digging and with bundles of energy, terriers can be a bit of a handful. This one is being entertained with a fast car ride.

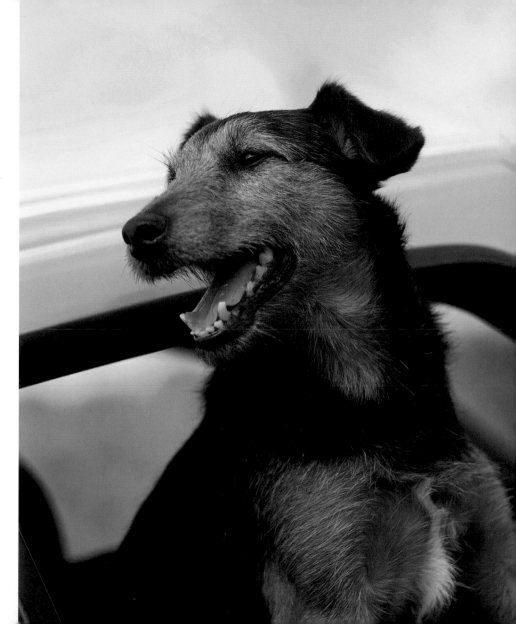

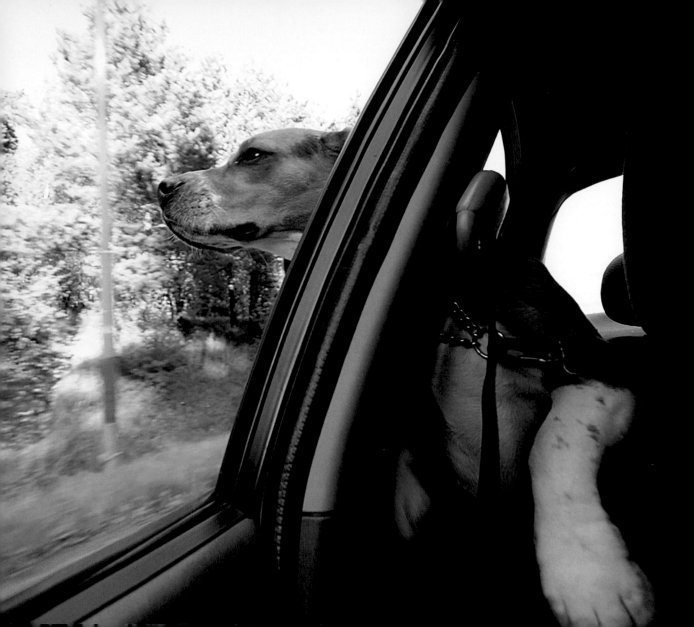

BEAGLE *(opposite)* One of the world's most famous dogs, Snoopy, was a Beagle. Purebred Beagles were bred to have white on their tail so that hunters could spot them when their heads were down to the ground following a scent.

DOBERMAN PINSCHER Tongue lolling and ears on end, this Doberman is letting loose. Sometimes misunderstood, this breed makes a fierce and effective guard dog but is a really big softie at heart.

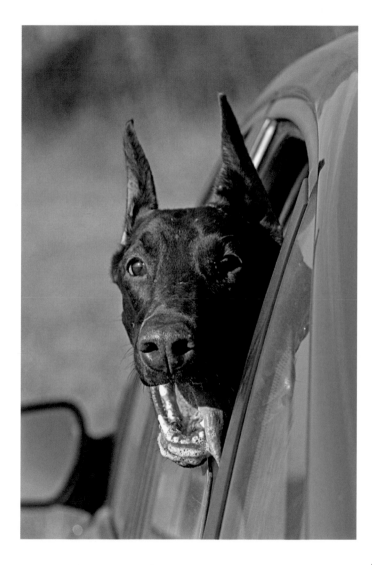

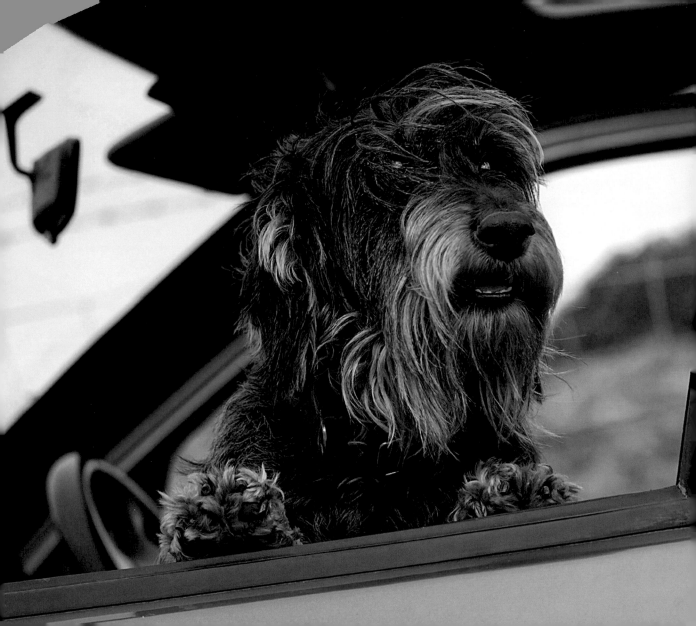

WIRE-HAIRED DACHSHUND

With bushy eyebrows and a beard on its chin, the Wire-haired Dachshund is a wise-looking fellow. Despite their little legs, these dogs have big personalities and a deep bark.

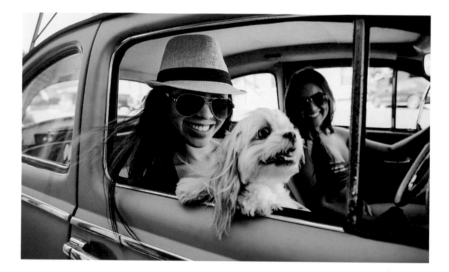

Time to hit the beach. Rocking the laid-back surf look, this little white cutie is ready to catch some rays.

YORKSHIRE TERRIER
(opposite) The 'Yorkie' is one of the most popular breeds of lapdog. Don't be fooled by the size of them; they have huge personalities and aren't afraid to show it with a bark or two – earning them the reputation of being very yappy!

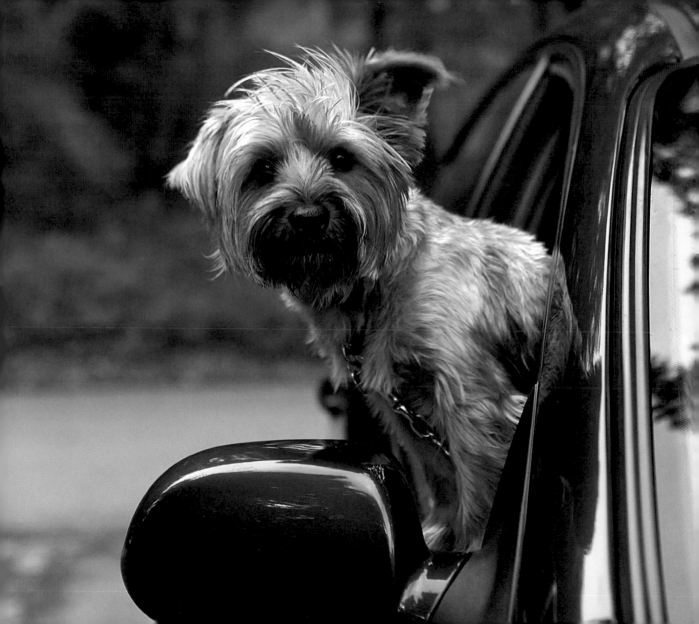

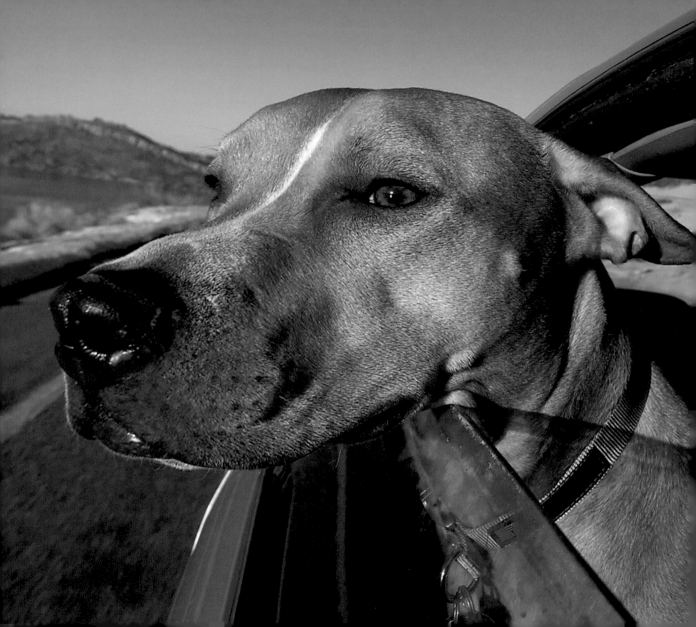

Clear eyed and blue skied.
Enjoying the crisp wintry air
of a lakeside road in Colorado.

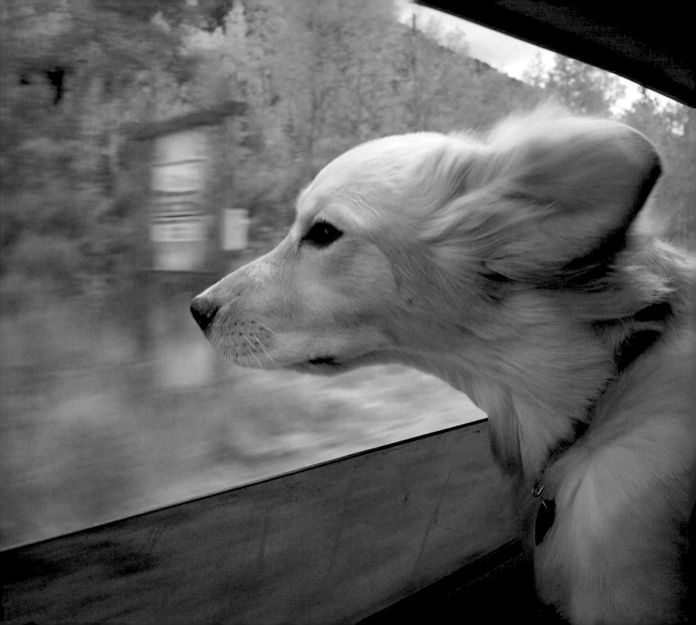

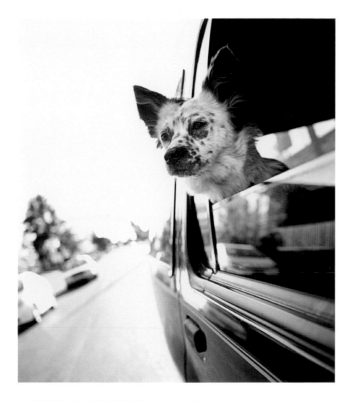

BORDER COLLIE MIX Soaking up the evening sunshine. The sheepdog takes the number one spot on the list of intelligent dogs.

GOLDEN RETRIEVER *(opposite)*
Riding the autumn breeze!

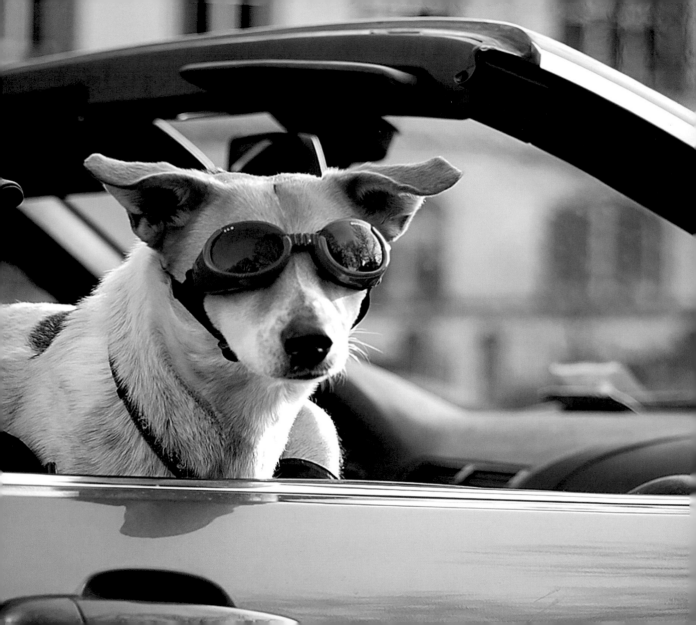

MIXED BREED A bespectacled dog taking a ride out on a cold spring day in Frankfurt. Driving goggles optional.

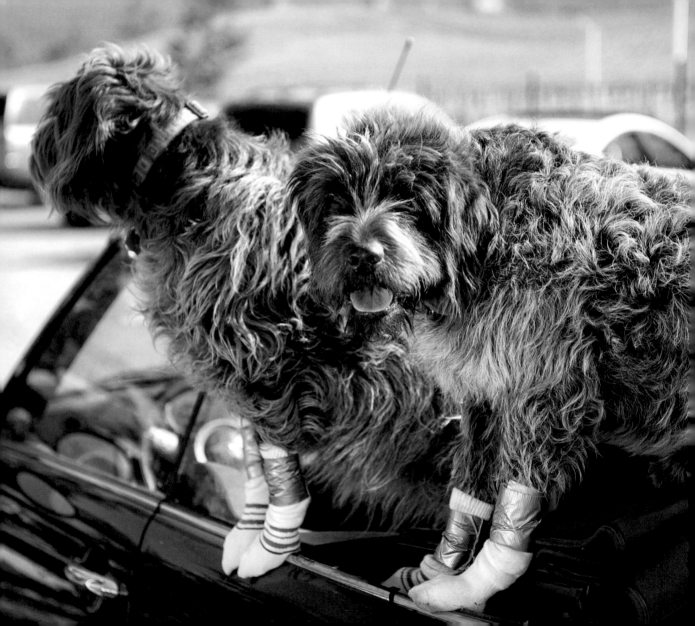

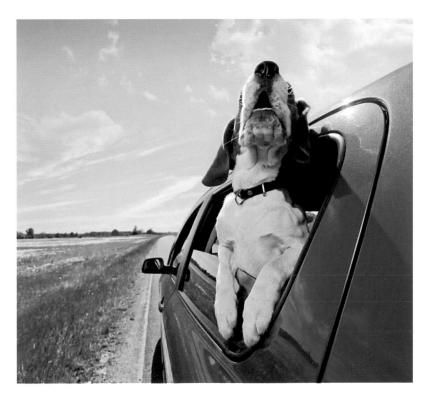

BEAGLE Sheer bliss. Drinking in
the blue skies and green pastures.

GRIFFON NIVERNAIS *(opposite)* Riding a cabriolet on
a hot day. (The socks are to prevent any scratches to the
car.) Once the favourite breed of King Louis IX, Griffon
Nivernais are one of the oldest French hunting dogs.

BLACK LABRADOR CROSS
Black Lab in a camper van,
chilling out California style.

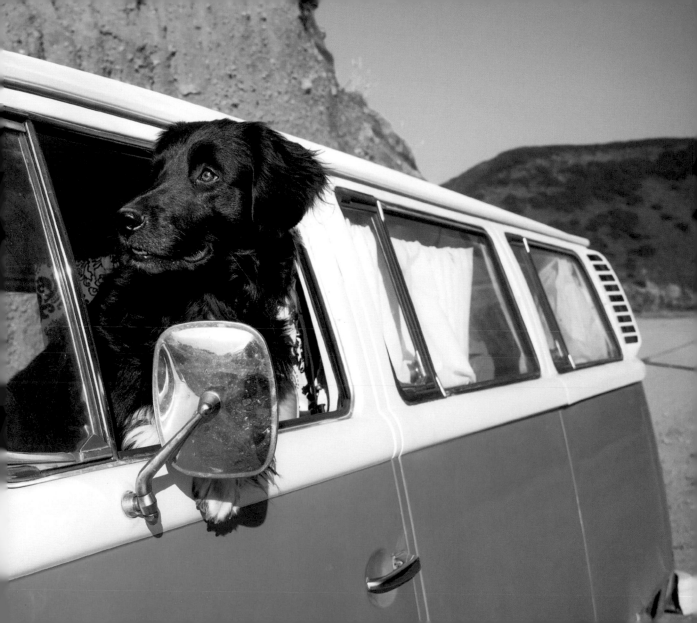

PIT BULL Pit Bulls have developed a reputation
as aggressive fighting dogs, but this is often as a
result of irresponsible owners. Pit Bulls remain
illegal in the UK.

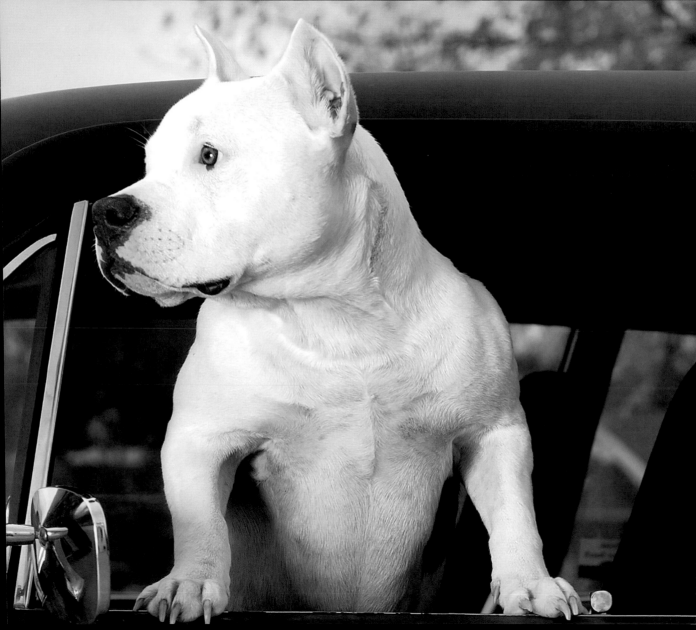

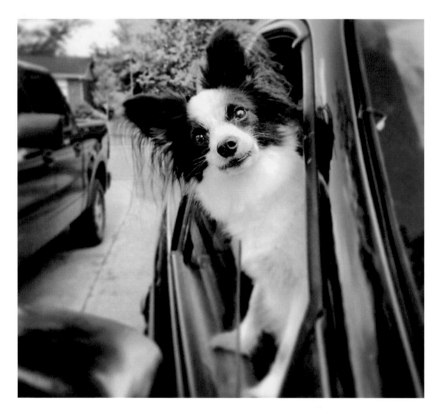

CHIHUAHUA COLLIE CROSS
Perked up and ready to roll.

ENGLISH BULLDOG (*opposite*) Like its French cousin, the English Bulldog is an easy-going pet who is very happy to take a nap on someone's lap. It's hard to believe that once these dogs were used primarily for fighting bulls.

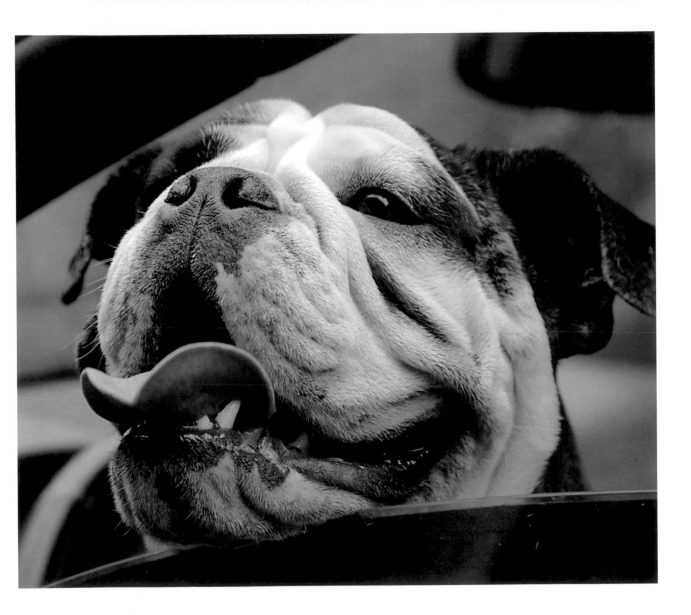

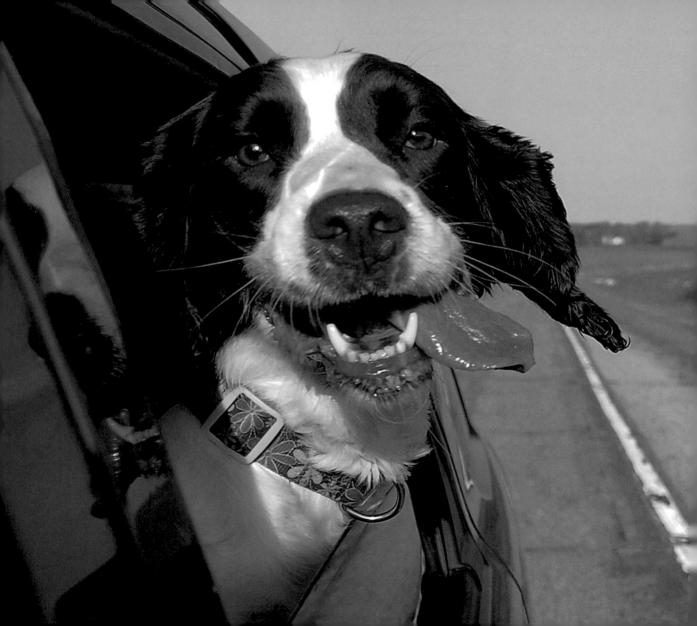

SPRINGER SPANIEL It's a dog's life.
The Springer is an amiable breed and this
one is enjoying a ride through the countryside.

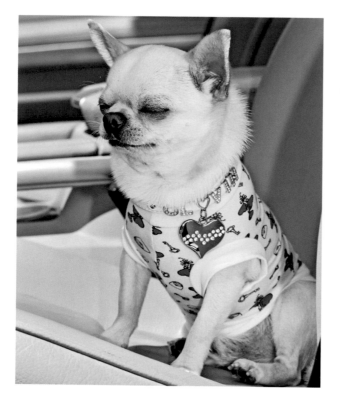

SMALL CHIHUAHUA Peace out. This is the world's smallest dog; a Chihuahua puppy can fit in the palm of your hand or even in a teacup. A cool t-shirt and some collar bling can add to the appeal.

A knowing look as this dog watches out of the window.

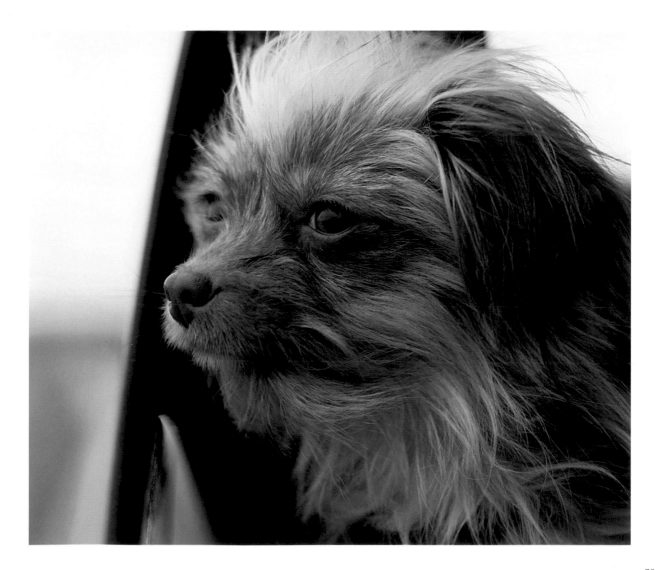

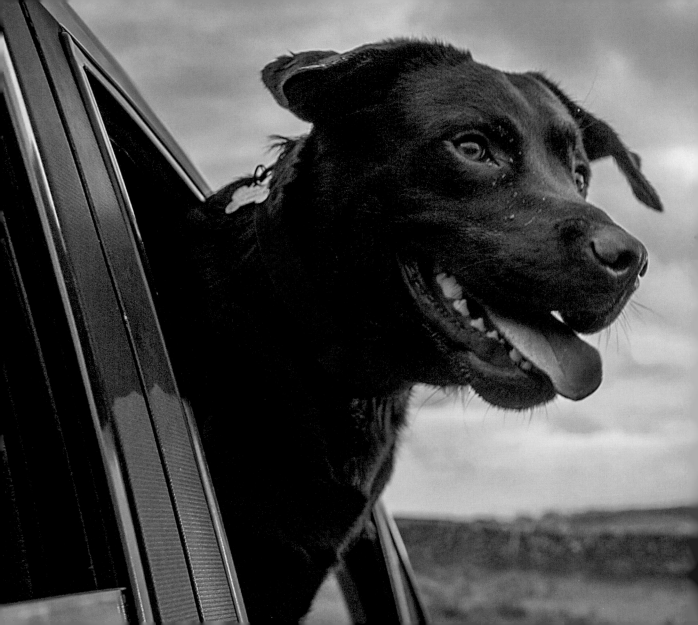

LABRADOR Young chocolate Lab panting in the Lake District sunset after a good long walk.

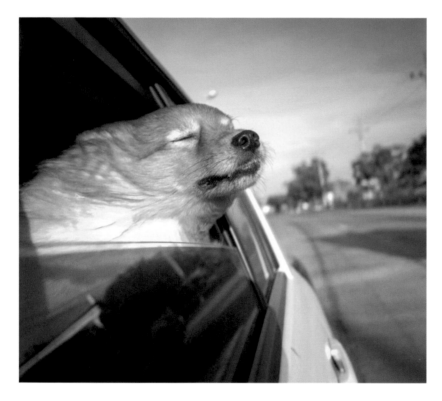

GOLDEN RETRIEVER MIXED BREED
Sweet ride!

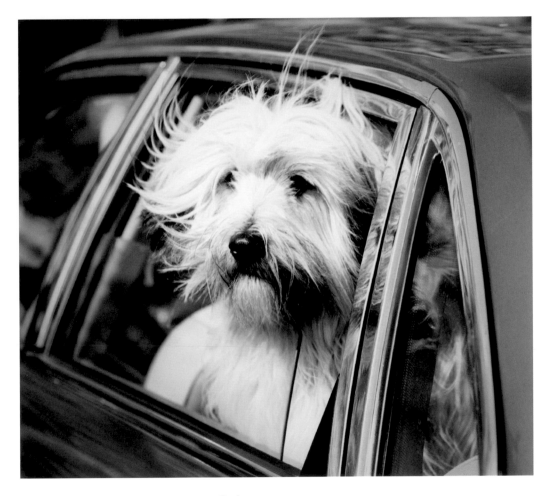

WEST HIGHLAND WHITE TERRIER Rather
sophisticated Westie with the wind in its hair – shot
in Cannes, Côte d'Azur, France.

ROMANIAN MIORITIC SHEPHERD DOG The big friendly giant. The Roman Mioritic Shepherd Dog hails from Romania's Carpathian Mountains and loves outdoor life. Forever devoted to its master, the Roman Mioritic is a watchdog and guardian at heart.

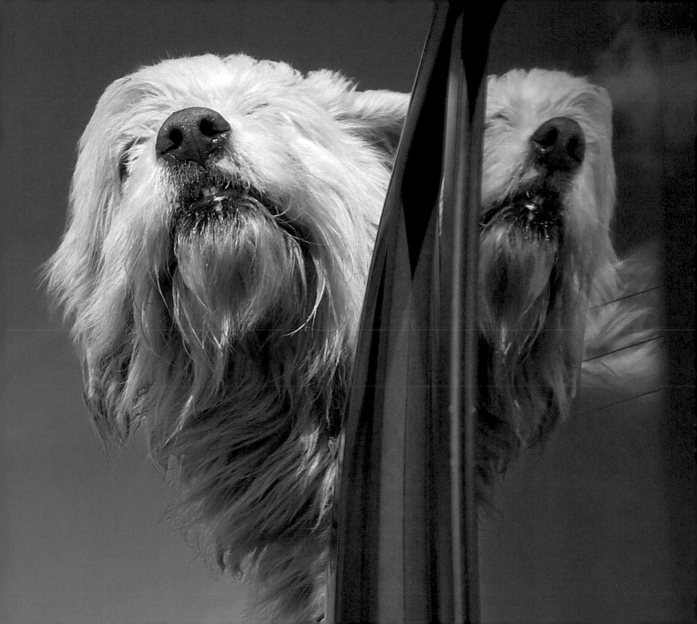

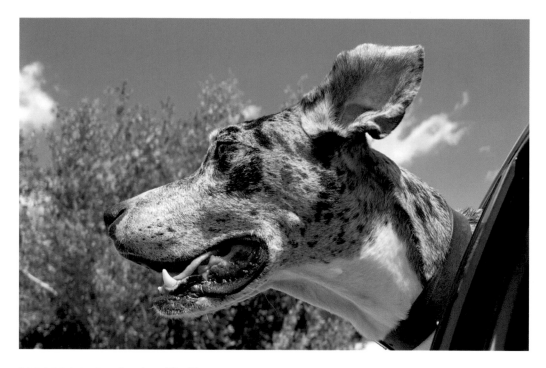

GREAT DANE A canine giant. The Great Dane is one of the world's tallest breeds. However, their size is no demonstration of aggression – Great Danes are also one of the most docile and affectionate dog breeds, causing them to be dubbed 'the world's biggest lapdogs'.

CHOCOLATE LABRADOR *(opposite)* The cocoa-coloured version of the Black Labrador is a friendly companion, but they do have notoriously big appetites so keep an eye on just how many doggy chocolates they devour!

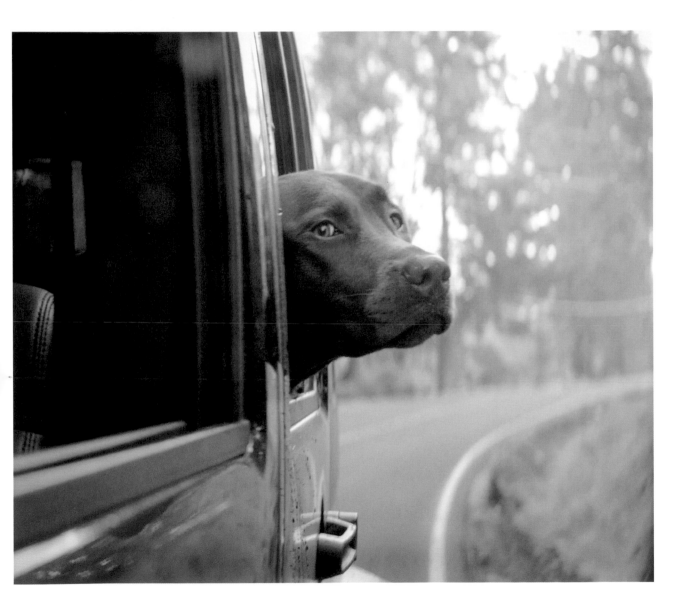

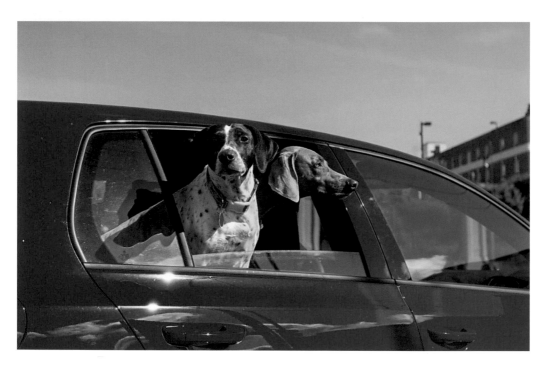

GUNDOG *(left)* AND WEIMARANER *(right)* Sunbathing pals.
Gundogs have an exceptional sense of smell and gentle mouths
to retrieve their prey. The Weimaraner has been nicknamed the
'silver ghost' due to its ethereal grey coat.

JACK RUSSELL BORDER TERRIER
CROSS *(opposite)* The wind in your hair,
the sun at your back and nothing but
the wide, open road… This is Midge.

JACK RUSSELL Satisfaction
guaranteed. Merry and fearless,
Jack Russells are renowned for
their high energy, drive and tough
spirits. As a hunt-driven dog,
they will pursue most creatures
they encounter.

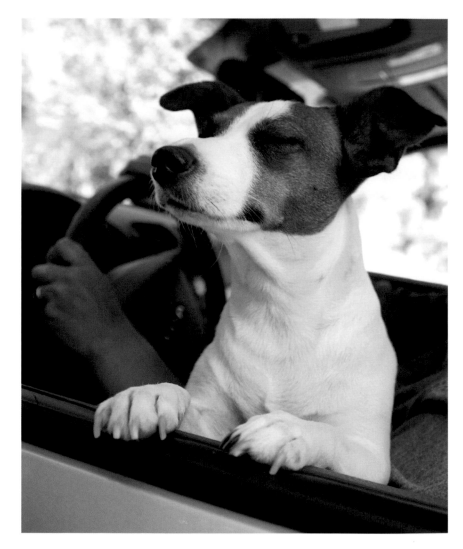

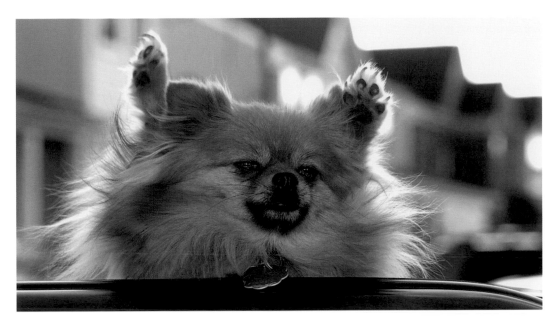

POMERANIAN The Pomeranian fluff-ball. A long and
straight outer coat, layered with a soft and thick undercoat
beneath, makes the Pomeranian a bouncy flouncy toy
dog. They can suffer from small-dog syndrome.

NEWFOUNDLAND The 'gentle giant'. Despite their size, Newfoundlands have very sweet temperaments, are fiercely loyal and are good with children, a trait that has been immortalised by Nana, the children's guardian in *Peter Pan*!

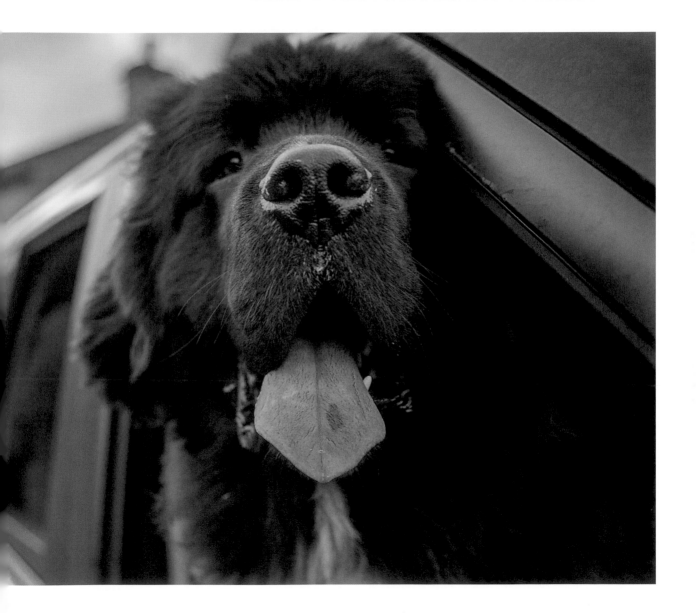

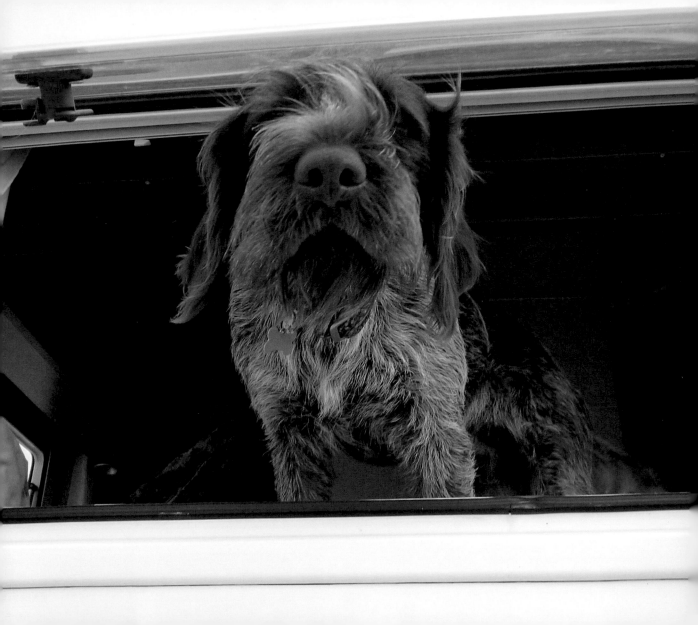

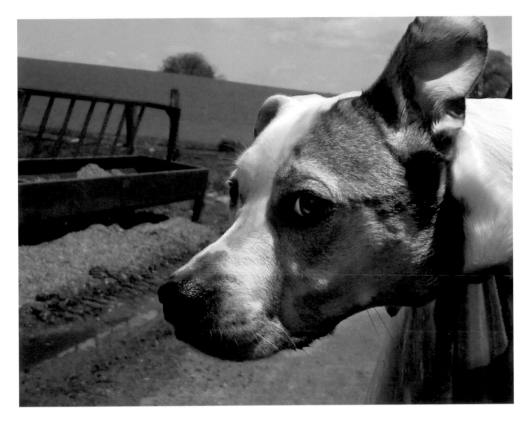

Cross Breed farm dog having fun on a country drive.

GERMAN WIRE-HAIRED POINTER *(opposite)*
These beardy companions are strong, dependable
and sometimes stubborn. This is Brian.

BLACK LABRADOR City slicker. Labs are exceedingly obedient and their high levels of alertness, intelligence and attentiveness mean they can be trained to do just about anything.

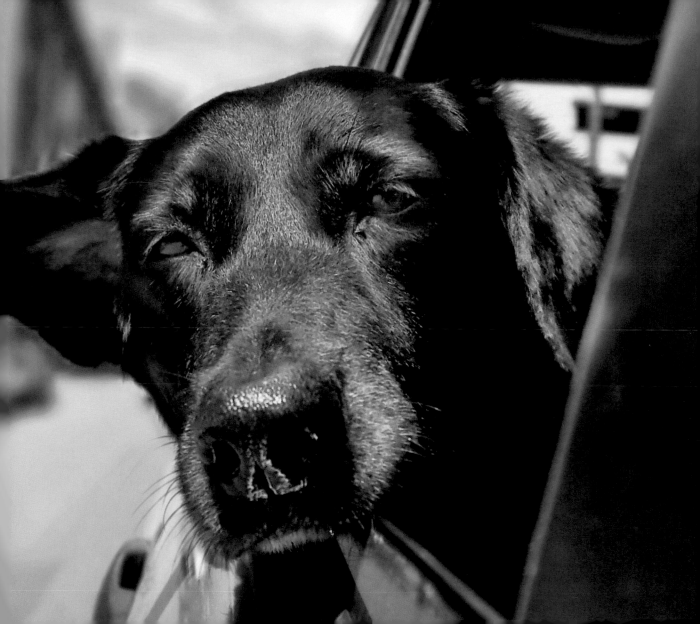

PUGS Sad-faced pugs were
a favourite of Queen Victoria.
The English painter William
Hogarth was also the devoted
owner of a series of pugs,
and even included one in
a self-portrait.

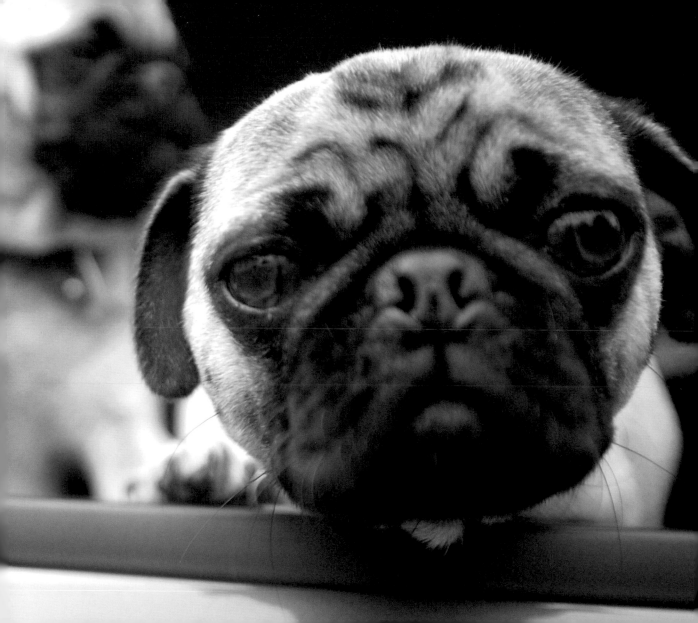

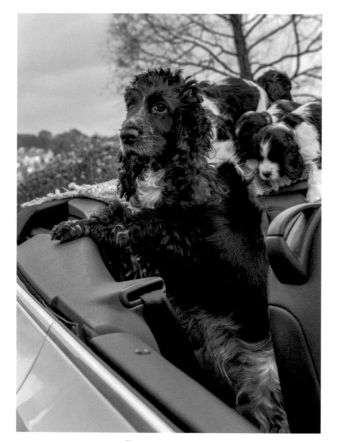

BLUE ROAN COCKER
SPANIEL 'Are we nearly
there yet?' A proud Mum
and her puppies take a break.

CAIRN TERRIER Scruffy and
sweet. *The Wizard of Oz* made
this breed a star – Toto is a
Cairn Terrier. There is no
place like home for this one
in Santa Barbara, California.

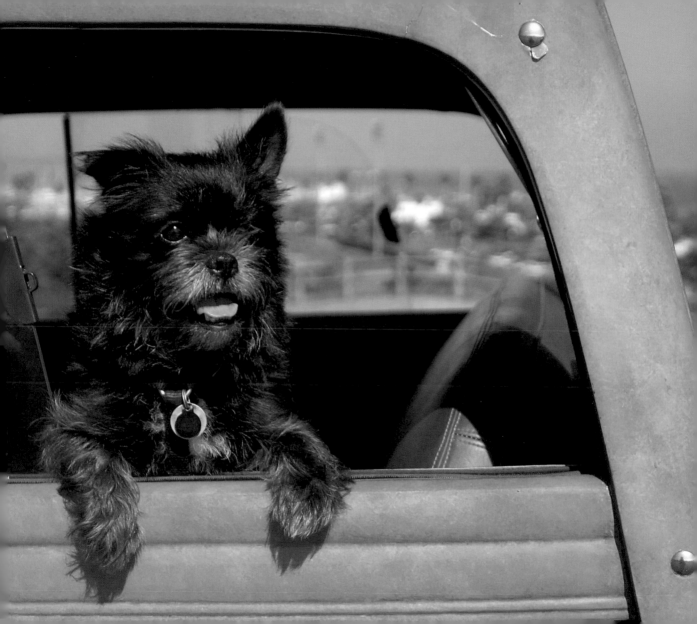

SHIH TZU These bouncy, happy and intelligent little dogs are thought to be a cross between the Lhasa Apso and the Pekingese.

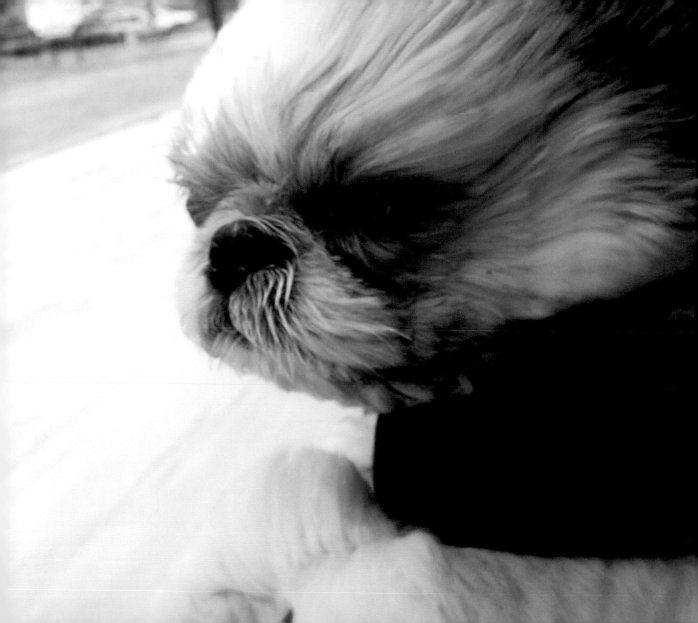

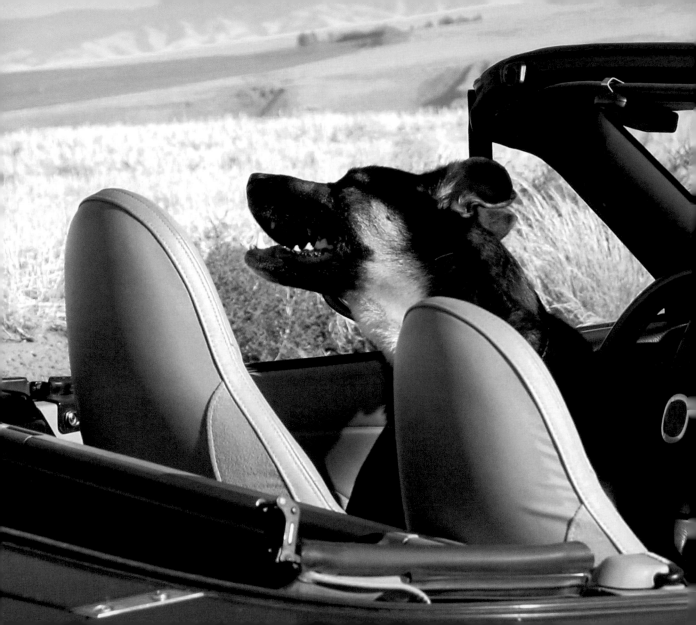

GERMAN SHEPHERD Also
know as Alsatians, these dogs
are immensely capable and
intelligent; they work with
the police and the military as
rescue and sniffer dogs as well
as being able to guide and assist
the disabled. However, they're
not all working dogs – this
one is enjoying the open
plains in a red convertible.

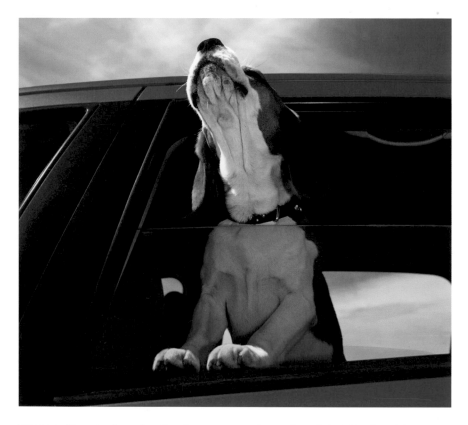

BEAGLE Blue-sky dreaming. Beagles are extremely gentle and placid in disposition, but, as hunting dogs, they forget everything else around them once they have picked up a scent. This one seems to have picked up the scent of sheer bliss!

LHASA APSO A taste of freedom. Big thrills in the open air.

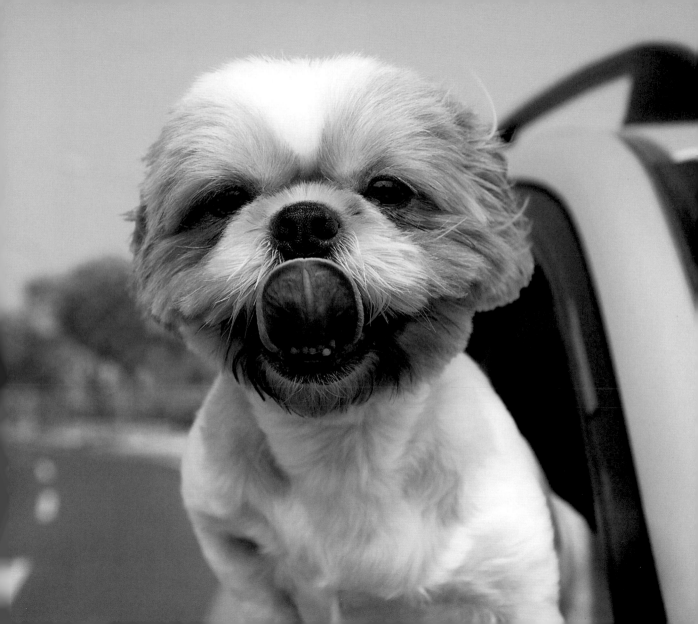

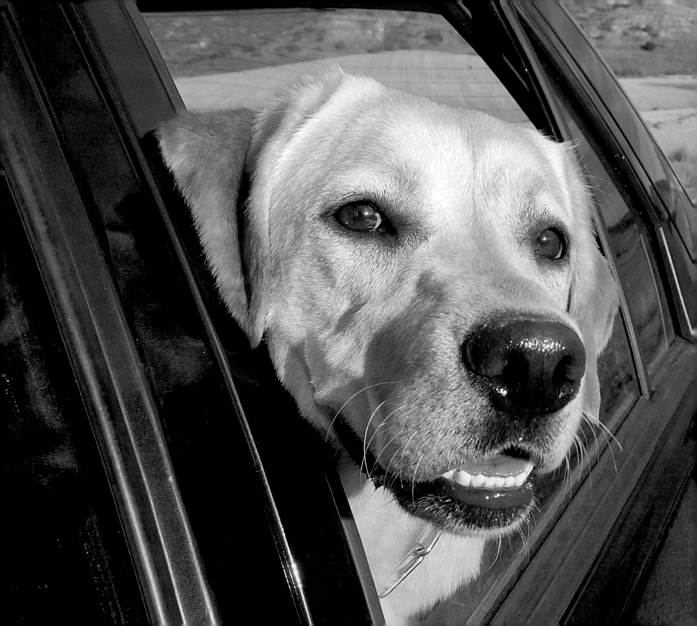

LABRADOR RETRIEVER
The lovely Lab is consistently
the most popular breed in the UK
and the US. Originally a working
dog breed, today Labradors are
fantastic guide and hearing dogs,
search and rescue dogs and loyal,
lovable companions.

LHASA APSO SHIH TZU
CROSS Scream if you want
to go faster. A wild ride for
a small dog.

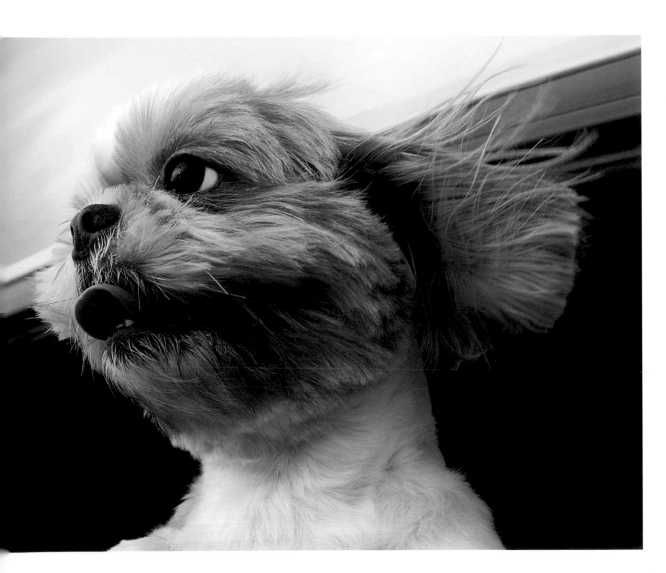

IRISH SETTER Also known as 'the red dog', these setters are high spirited and like to be occupied. Originally a hunting dog but now more likely to make an enthusiastic and exuberant companion.

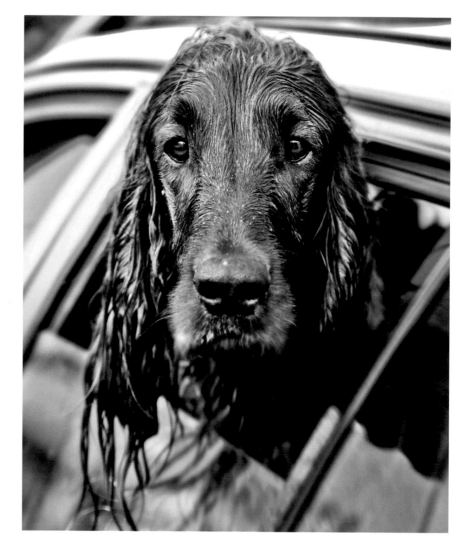

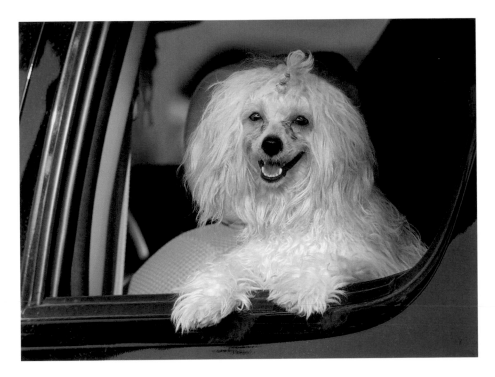

POODLE Sporting its weekend casual look, this primped
and preened young Poodle poses for the camera. The
Poodle is an elegant and impressive breed that has won
Best in Show at Crufts on several occasions. Beneath
all the glamour they are clever family dogs.

SAMOYED Samoyeds began
hauling sledges and herding
reindeer across the Siberian
ice. They are the perfect
playmates for children, in fact
their playful nature and gleeful
expression has earned them
the nickname 'Sammie Smile'.

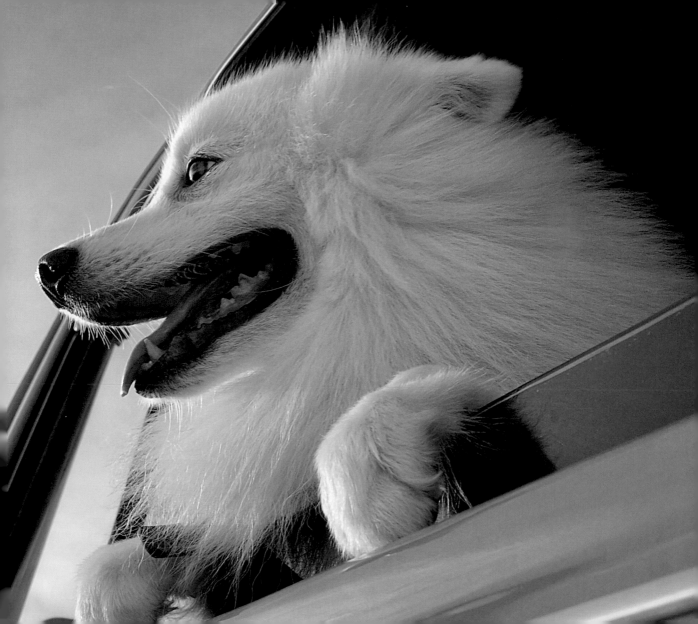

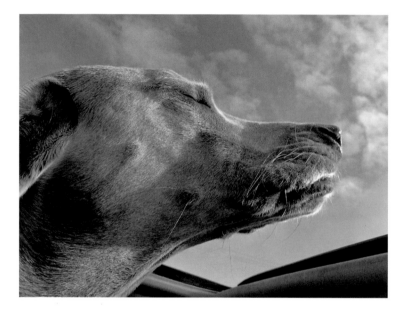

WEIMARANER CROSS Weims are people dogs. They are high-spirited and high-maintenance pets that can become very pesky with shoes and furniture if not walked and trained properly.

STAFFORDSHIRE BULL TERRIER *(opposite)* Seeing double. Descended from dog-fighting ancestors, the 'Staffie' is robust, loyal and stubborn. Possessing great courage, these dogs have developed from pit-fighting to people-loving.

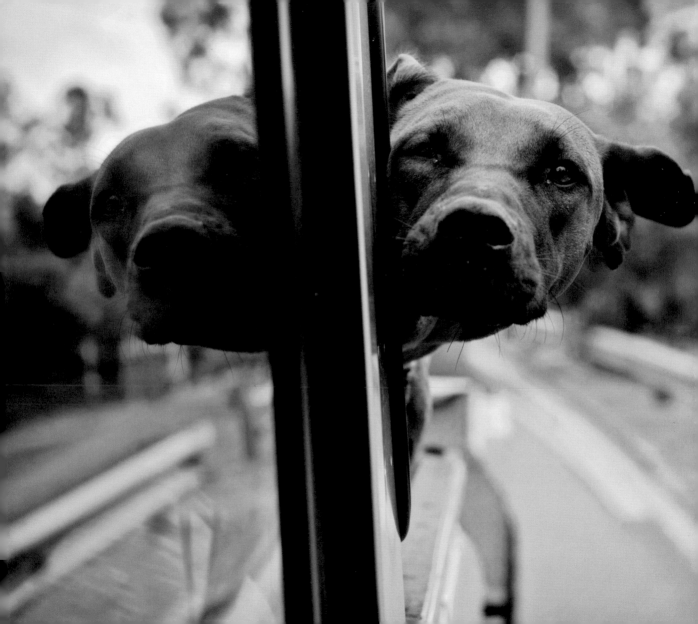

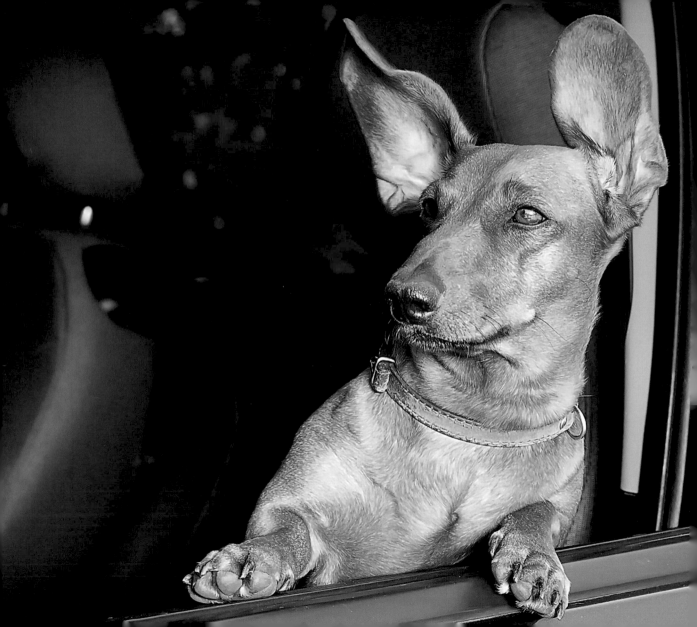

SEGUGIO ITALIANO *Viva la vita!* This Italian hound has discovered that long ears can be a great windbreak.

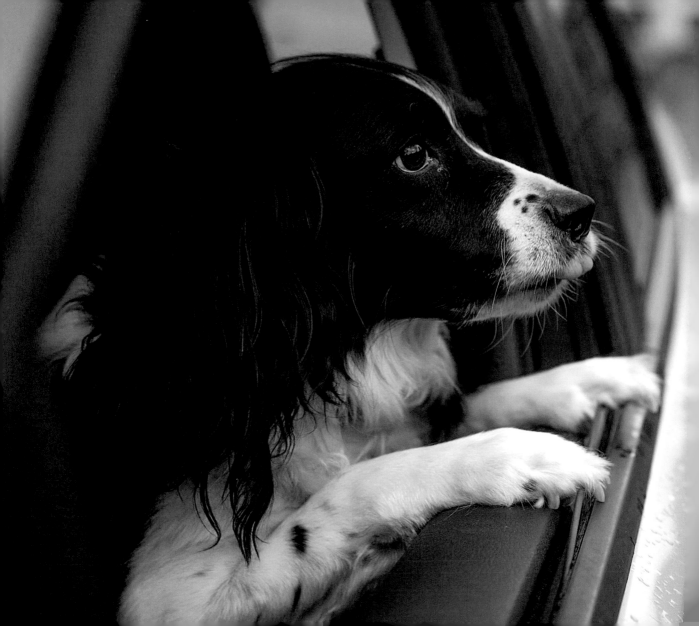

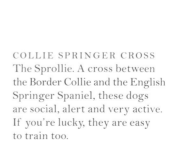

COLLIE SPRINGER CROSS
The Sprollie. A cross between
the Border Collie and the English
Springer Spaniel, these dogs
are social, alert and very active.
If you're lucky, they are easy
to train too.

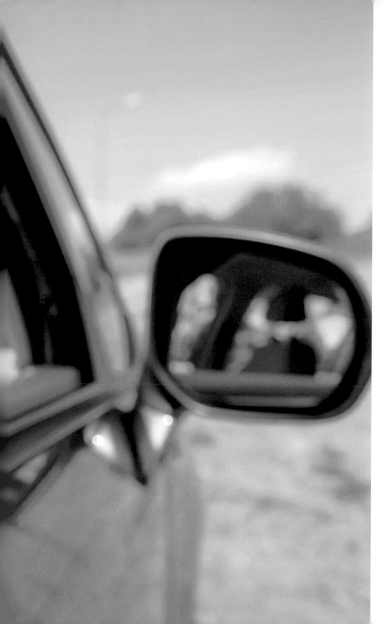

MALTESE Sitting pretty. A very popular lapdog, the Maltese thrives on love and affection. But don't be deceived – under all that shiny white hair is an energetic animal and this breed often competes in agility competitions.

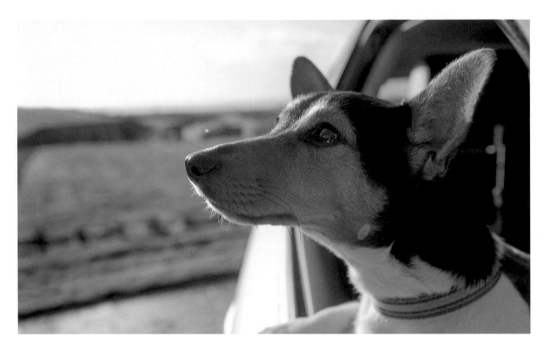

JACK RUSSELL The Jack Russell was bred to flush foxes out from their holes, and consequently this breed is very intelligent and has a lot of energy. They need extensive training if they are ever to learn to listen to His Master's Voice. This is Tilly.

WHIPPET *(opposite)* Reaching for the skies. The Whippet's exhilarating speed made it the hunter's best friend and a reliable racing dog. Nevertheless, they are quite content to relax and make brilliant pets.

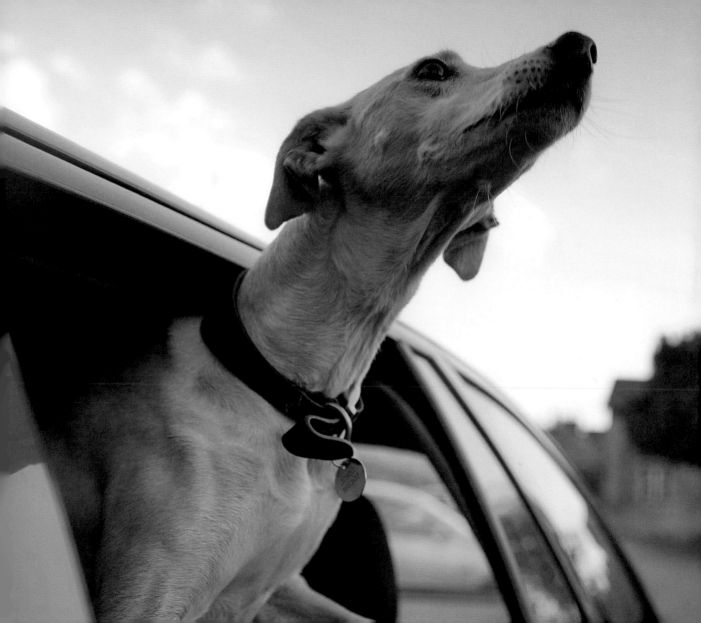

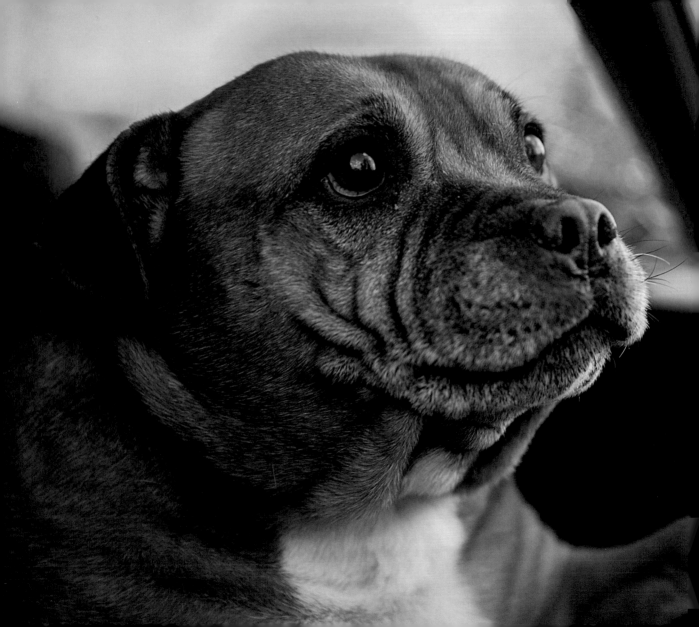

STAFFORDSHIRE BULL
TERRIER Like the American
Pit Bull Terrier, 'Staffies'
have acquired a reputation as
fighting dogs. Although they
were originally bred for bull
baiting, Staffs are very clever
and loving and become worried
(like this one) when separated
from human attention.

BULLDOG Stiff upper lip. Sturdy, calm and dignified, this easy-going and loving companion dog has become part of the British identity, both in name and image.

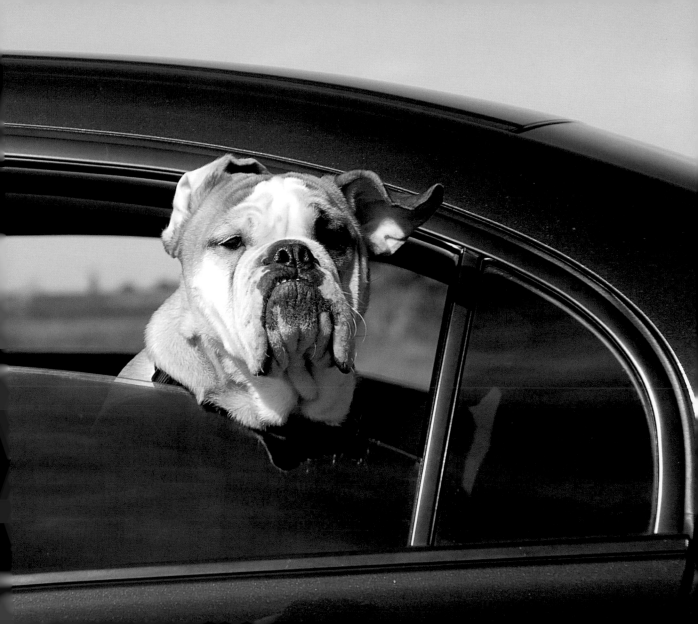

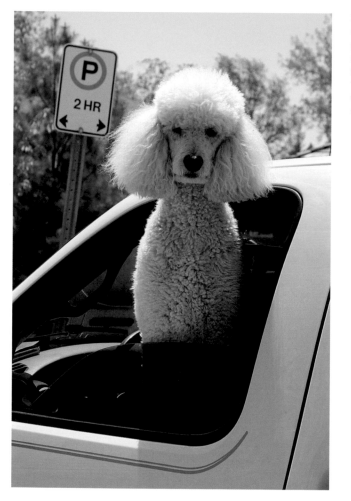

POODLE An inquisitive Poodle standing tall. Despite being perfectly groomed, they were originally used to fetch waterfowl for hunters. The English name 'Poodle' is derived from the German word *pudel*, or *pudelin*, which means to splash in the water.

BORDER COLLIE *(opposite)* Collies are the athletic workaholics of the dog world. They demand plenty of mental and physical exercise – just make sure you can keep up. This is Cathy.

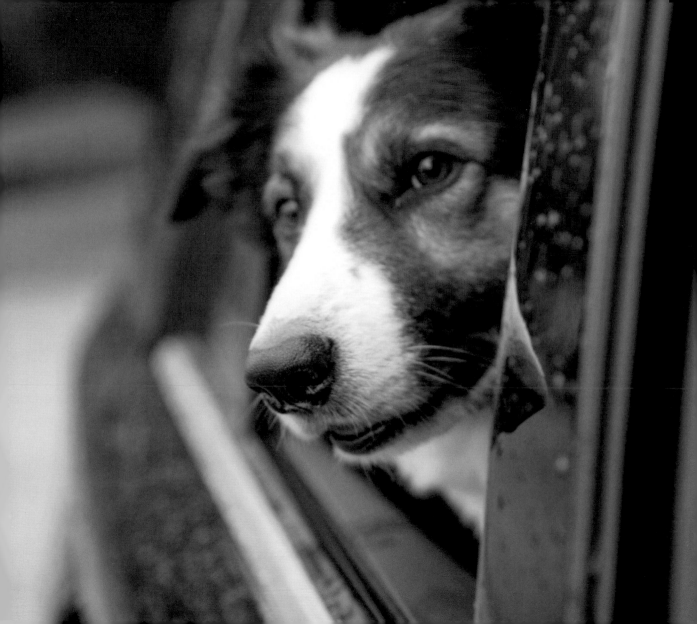

WORKING COCKER SPANIEL
With its shiny coat, adorable
temperament and trademark
ears, the Cocker Spaniel is not
only one of the most popular dog
breeds in the UK but it is also the
breed that has won most Best in
Show awards at Crufts.

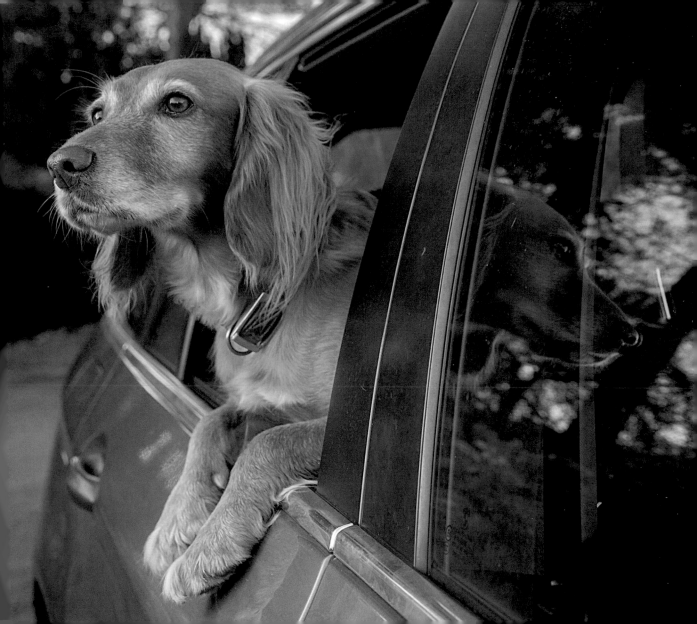

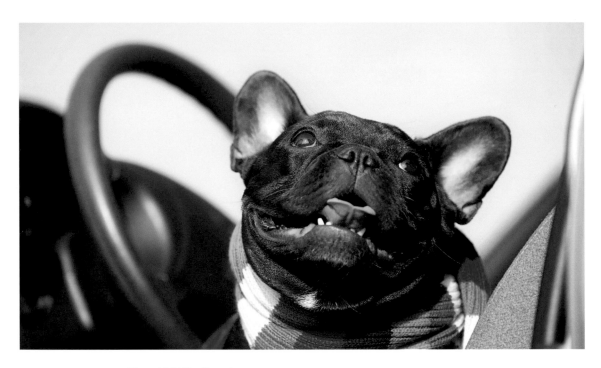

FRENCH BULLDOG 'Frenchie'. The French
Bulldog was bred by lace makers in the 1800s
in England and then in France. They are playful,
comic characters who like to clown around.

This is Roscoe peering out
onto an atmospheric scene.

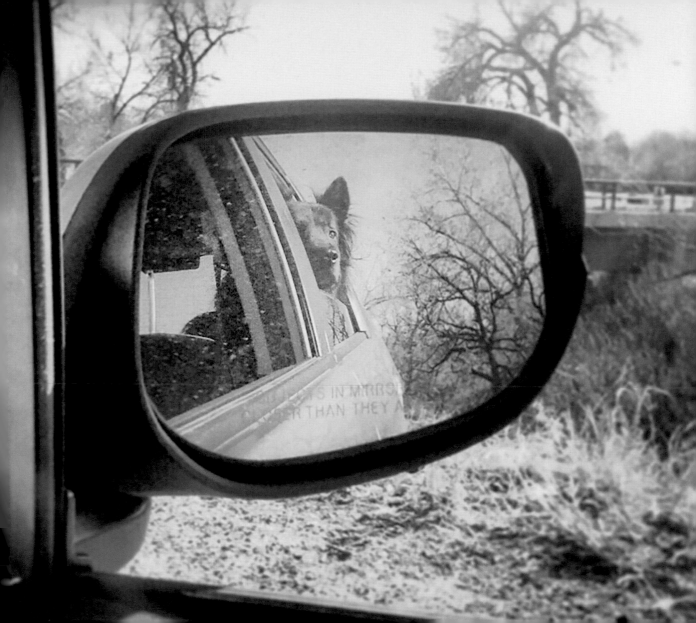

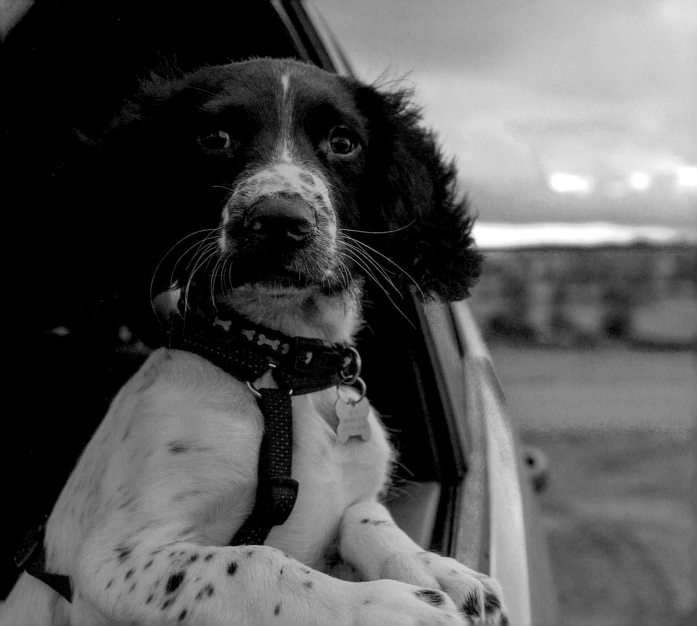

SPRINGER SPANIEL Springers are
enthusiastic and eager to please. This curious
puppy looks out onto the English countryside.

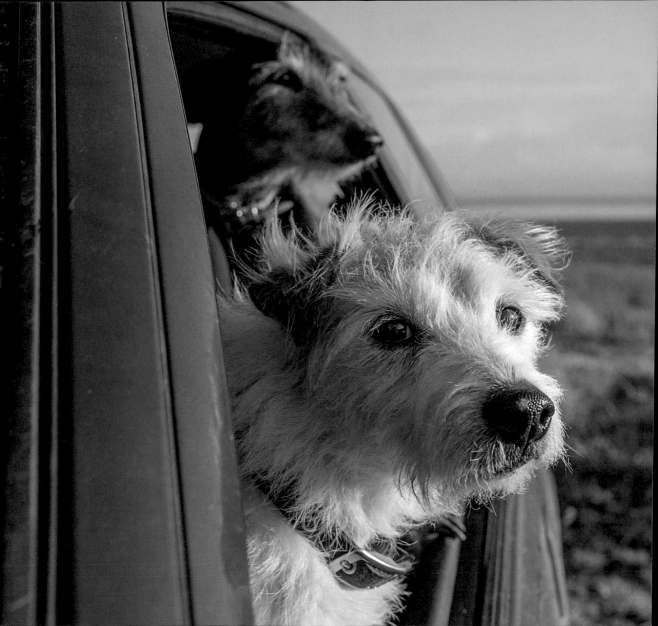

LURCHER *(left)* AND JACK RUSSELL CROSS *(right)* The quickest way to a Lurcher's heart is through attention and food. The key to a Jack Russell's heart is to keep him occupied!

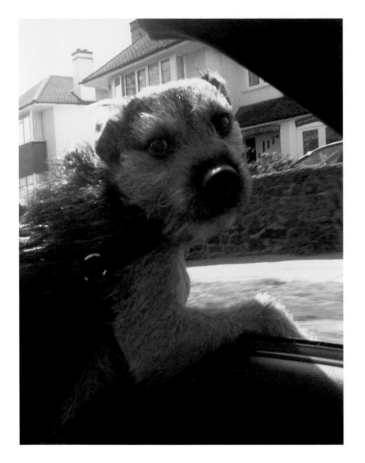

BORDER TERRIER Rein
him in! A little terrier loving
the ride. This is Frank.

BLOODHOUNDS
(opposite) Known in
France as the *Chien de
Saint-Hubert*, this breed
has a trademark wrinkly
face, droopy ears and an
amazing sense of smell.
This is Madison and
Guinness, of Mid-Hudson
Bloodhound Refuge.

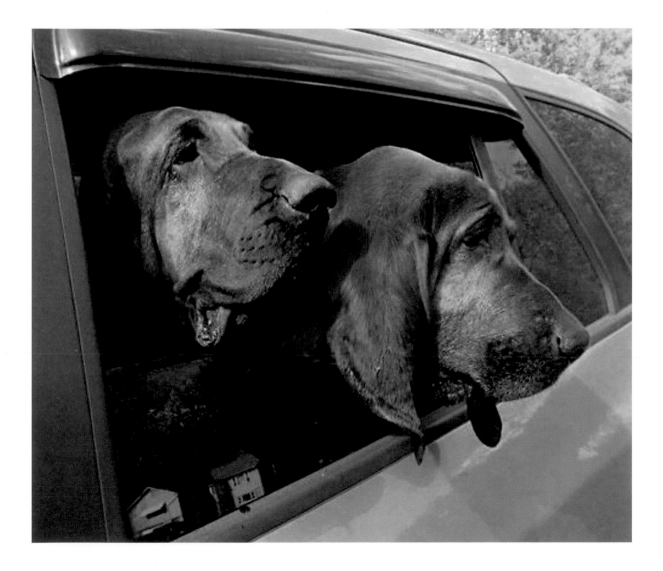

BEAGLE A happy traveller on the road to Itá City, Santa Catarina State in Brazil. This is Jack, aged four – strapped in with a special safety belt for dogs!

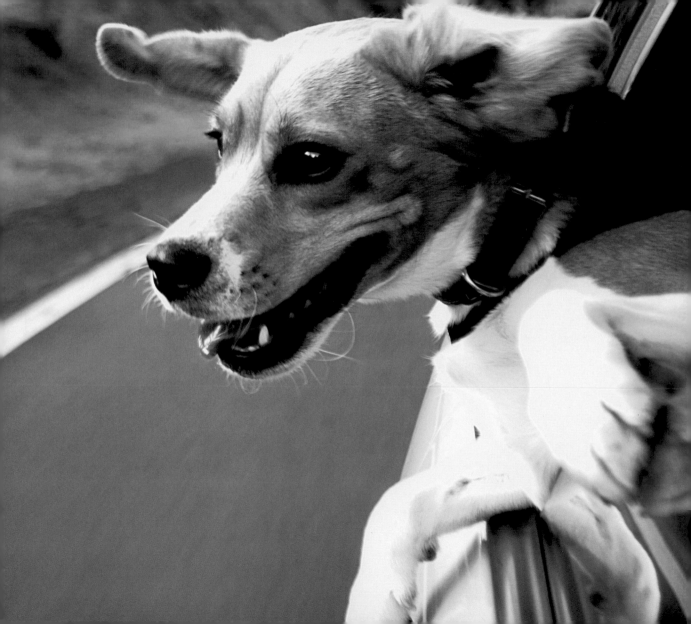

WHEATEN TERRIER Once referred to as the 'Poor Man's Wolfhound', the Wheaten Terrier is in fact wealthy in its abilities. In Ireland it was originally used for watching and herding livestock and today the breed takes part in agility, obedience and tracking competitions.

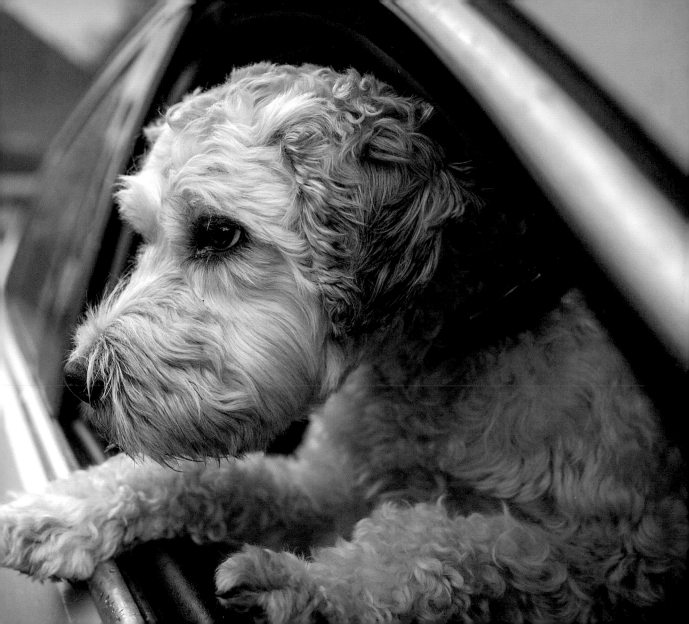

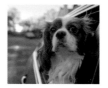

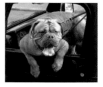
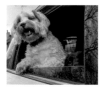
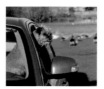
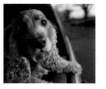
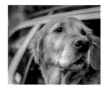
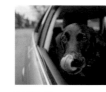
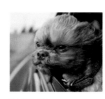
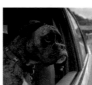

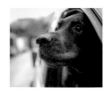

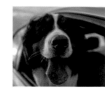
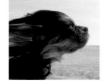
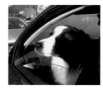
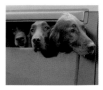

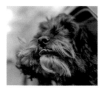

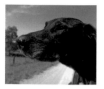

PAGE 36
Black Labrador

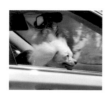

PAGES 40–41
Poodle

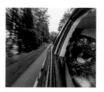

PAGE 45
German Shepherd

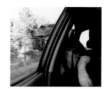

PAGE 50
Beagle

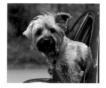

PAGE 55
Yorkshire Terrier

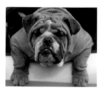

PAGE 37
Bulldog

PAGE 42
Miniature Pinscher

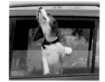

PAGE 46–47
Beagle

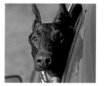

PAGE 51
Doberman Pinscher

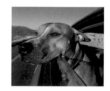

PAGES 56–57

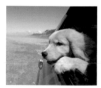

PAGE 38
Golden Retriever

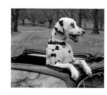

PAGE 43
Dalmatian

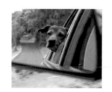

PAGE 48

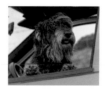

PAGES 52–53
Wire-haired
Dachshund

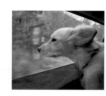

PAGE 58
Golden Retriever

PAGE 39
Chihuahua Mix

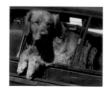

PAGE 44
Golden Retriever
Mixed Breed

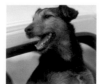

PAGE 49
Rough-Coated Terrier
Cross

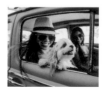

PAGE 54

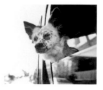

PAGE 59
Border Collie Mix

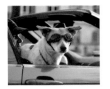

PAGES 60–61
Mixed Breed

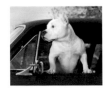

PAGES 66–67
Pit Bull

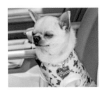

PAGE 72
Small Chihuahua

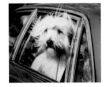

PAGE 77
West Highland White
Terrier

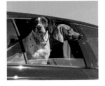

PAGE 82
Gundog and
Weimaraner

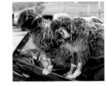

PAGE 62
Griffon Niverais

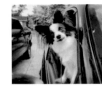

PAGE 68
Chihuahua Collie
Cross

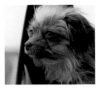

PAGE 73

PAGES 78–79
Romanian Mioritic
Shepherd Dog

PAGE 83
Jack Russell Border
Terrier Cross

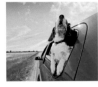

PAGE 63
Beagle

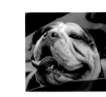

PAGE 69
English Bulldog

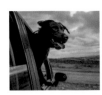

PAGE 74–75
Labrador

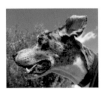

PAGE 80
Great Dane

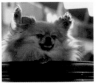

PAGE 84
Jack Russell

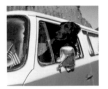

PAGES 64–65
Black Labrador Cross

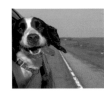

PAGES 70–71
Springer Spaniel

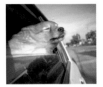

PAGE 76
Golden Retriever
Mixed Breed

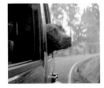

PAGE 81
Chocolate Labrador

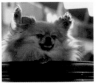

PAGE 85
Pomeranian

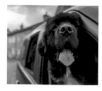

PAGES 86–87
Newfoundland

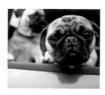

PAGES 92–93
Pugs

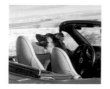

PAGES 98–99
German Shepherd

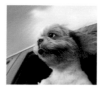

PAGE 104–105
Lhasa Apso Shih Tzu
Cross

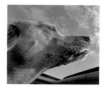

PAGE 110
Weimaraner Cross

PAGE 88
German Wire-haired
Pointer

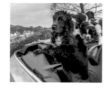

PAGE 94
Blue Roan Cocker
Spaniel

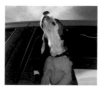

PAGE 100
Beagle

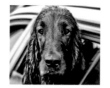

PAGE 106
Irish Setter

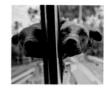

PAGE 111
Staffordshire Bull
Terrier

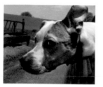

PAGE 89

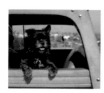

PAGE 95
Cairn Terrier

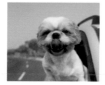

PAGE 101
Lhasa Apso

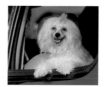

PAGE 107
Poodle

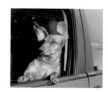

PAGES 112–113
Segugio Italiano

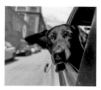

PAGES 90–91
Black Labrador

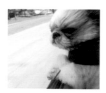

PAGES 96–97
Shi Tzu

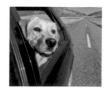

PAGES 102–103
Labrador Retriever

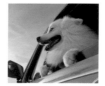

PAGES 108–109
Samoyed

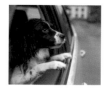

PAGES 114–115
Collie Springer Cross

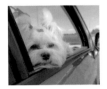

PAGES 116–117
Maltese

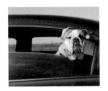

PAGES 122–123
Bulldog

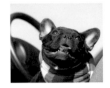

PAGE 128
French Bulldog

PAGE 134
Border Terrier

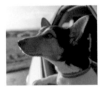

PAGE 118
Jack Russell

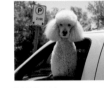

PAGE 124
Poodle

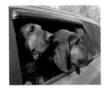

PAGE 129

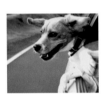

PAGE 135
Bloodhound

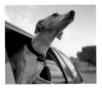

PAGE 119
Whippet

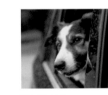

PAGE 125
Border Collie

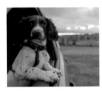

PAGES 130–131
Springer Spaniel

PAGES 136–137
Beagle

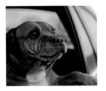

PAGES 120–121
Staffordshire Bull
Terrier

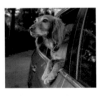

PAGES 126–127
Working Cocker
Spaniel

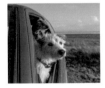

PAGES 132–133
Lurcher
Jack Russell Cross

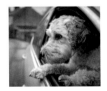

PAGES 138–139
Wheaten Terrier